**IMAGES**
*of America*

# LARAMIE

7/10/07
To Norman
Ride on Cowboy,

Charlie Petweer

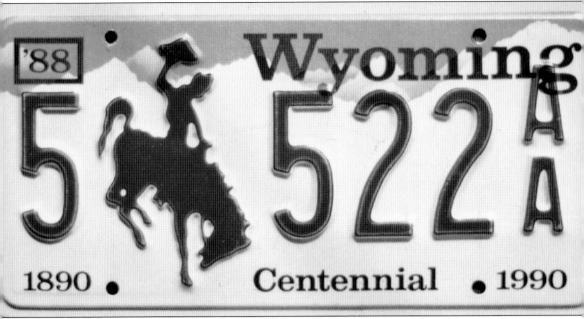

**A HORSE THAT BUCKS.** Wyoming license plates have had this design since 1935. The number at the left center denotes the county. Initially the license had four numbers, but as the population grew, four numbers were not enough. The license plates were changed to have three numbers and a single letter A to Z, then double letters A to Z. For those wishing for letters only, they could have up to four letters of their choice.

**ON THE COVER:** Albany County held its first official roundup in 1877, and it became an annual event for the ranches. Each fall, the cattle were driven off the range, gathered together, and shipped to market. It usually took four or five weeks to complete a roundup, and it was all extremely hard work. Each of the cowpokes involved in the roundup usually had a string of four or five horses to get him through each day. It was not unusual for a cowboy to ride as much as 75 miles a day, handling and turning those ornery critters, which were all hell-bent on escape. The chuck wagon followed the men, ready to feed each one of them three times a day. Breakfast consisted of flapjacks, coffee, and bacon, which was thickly sliced from the rind. Lunch and supper tended to be somewhat repetitious and monotonous. These meals included beef, beans, biscuits made from scratch, and coffee strong enough to float an egg. (Courtesy of the Laramie Plains Museum.)

IMAGES
*of America*

# LARAMIE

Charlie Petersen and the
Laramie Plains Museum

ARCADIA
PUBLISHING

Published by Arcadia Publishing
Charleston SC, Chicago IL, Portsmouth NH, San Francisco CA

Printed in the United States of America

Library of Congress Catalog Card Number: 2007923090

For all general information contact Arcadia Publishing at:
Telephone 843-853-2070
Fax 843-853-0044
E-mail sales@arcadiapublishing.com
For customer service and orders:
Toll-Free 1-888-313-2665

Visit us on the Internet at www.arcadiapublishing.com

*This book is dedicated to Charlie L. Petersen, my uncle, who is indeed the "Old Man of the Mountains."*

*This book is also dedicated to all the volunteers—beginning with Laramie Woman's Club's quest to "Save our Treasures" in 1898, to the development of an Albany County Historical Society and a visionary Museum Association, and to all those who have given of their time and talent through the years. Here is a wonderful compilation of your labors.*

*It is also dedicated to Edward and Jane Ivinson, on whose extraordinary property the Laramie Plains Museum and so much of Laramie's special history is showcased.*

# CONTENTS

# ACKNOWLEDGMENTS

This project would have been impossible without the coordination of Connie Lindmier, the present curator of the Laramie Plains Museum. Her patient help with the photograph searches and chapter building was invaluable. I am grateful for the editing expertise of Joney Wilmot, Myrna Brandt, and Mary Mountain, as well as Ani Metreveli's work with scanning and organizing photographs. It takes many eyes to make sure we are not missing something in a project of this magnitude. The fact that the museum staff was so willing to work to make this happen, as part of their "Faces and Voices" emphasis, made this special endeavor come to life. Many thanks go to Hannah Carney of Arcadia Publishing, whose expertise guided the Laramie team through the whole project from beginning to end.

Many thanks also go for the photographs furnished by the American Heritage Center at the University of Wyoming; Anne Brandt with the Ludwig Collection; E. J. Bouse; the Margery House Collection; the Charlie Petersen collection; photographs furnished by Richard Eberhart, Julie Williams, Pat Madigan, and George Powell, the Union Pacific Railroad; the 133rd Army Engineers company of the Wyoming National Guard; the Ivinson Home for Aged Ladies; the Albany County Public Library and the use of the city directories from 1897 to 1995; the First Baptist and United Methodist Churches of Laramie; Spiegelberg Lumber and Building Company; the Bud Pownell of Cody, Wyoming, collection; Bill Dalles's hands-on demonstration of cattle branding; Jim Bosler's knowledge of historic sheep ranching in Albany County; and Dan Nelson's knowledge of Laramie history. Not to be forgotten are the use of the author's collection of the 1931, 1948, 1950, and 1951 editions of the *WYO*, the University of Wyoming's annual yearbook.

Finally, I must express my sincere gratitude for the use of the following very special resources on Laramie's history: Mae Urbanek's book, *Wyoming Place Names*; Mary Kay Mason's book *Laramie—The Gem City of the Plains*; *The Laramie Story* by Mary Lou Pence; Maurice Frink's *Cow Country Cavalcade*; Al Larson's *History of Wyoming*; and Velma Linford's *WYOMING Frontier State*.

# INTRODUCTION

The year was 1819, or thereabouts, and a French Canadian trapper by the name of Jacques LaRamee headed out for another season to trap beaver. He set up camp in the western part of the Dakota Territory, along a river that would eventually carry a corruption of his name—Laramie. This area would later become the Wyoming Territory. The Arapaho Indians, nomadic as they were, had lived and worked this land from time immemorial and felt that this whole area belonged to them. When they discovered this white man trapping beaver on their land, they murdered LaRamee, chopped a hole in the ice covering the river, and stuffed his body through the hole and into the water, hoping that the body would not be discovered until spring.

Several locations would be named after the Frenchman, including a town, the high plains surrounding the town of Laramie, a mountain peak, one of the original counties in the territory, and a fort in eastern Wyoming Territory, simply because of where the "LaRamee" river flowed. Laying track at a rate of about 10 miles a day, the Union Pacific helped build the transcontinental railroad. When the UP located their track 40 miles west of Cheyenne, they created another tent town to service the railroad workers. Since the town was located next to the Laramie River, it was called Laramie.

Those hardy souls riding the first train from Omaha to Laramie City on May 10, 1868, were in for a severe case of culture shock. Except for the slight break in scenery when the tracks crossed the Laramie Range, they were mostly surrounded by endless prairie. It must have been somewhat overpowering, totally awesome, and, to some, even frightening. For as an old dying cowpoke was heard to say, "Oh, bury me not on the lone prairie, where the wild coyotes will howl o'er me."

That first train carried one of the city's founding fathers, whose name was Edward Ivinson. He and his wife, Jane, stepped off the train—somewhat dismayed at the vastness of the prairie and the everlasting wind. Ivinson started out in the mercantile business, but it wasn't long until he found his true callings—banking and brokering in ties for the Union Pacific. As a result, he became a kingpin in Laramie's development, and he remained thus until his retirement in 1921.

Congress approved the Wyoming Organic Act on July 25, 1868, but because of differences of opinion with Pres. Andrew Johnson over political appointees, Wyoming did not become a territory until April 15, 1869. For the next decade, Wyoming's tenuous survival as a territory was nothing short of a crapshoot. There seemed to be no solution to the so-called Native American problem, and the Union Pacific was anything but friendly with the new territory. Laramie's very sparse population fought for its survival. However, somewhere along the way, the gods must have smiled down on this wild and woolly land. By 1880, the territory's existence had become secure, and by then, Laramie was a prominent stopover along the Union Pacific Railroad.

Actually, during those early years, Laramie fared better than the territory. Right next to the tracks, the railroad built a nice depot, hotel, and a roundhouse to repair their steam engines. They ran a water line from the city springs east of town to bring in water for their engines. There was a lot of growth in the city during the 1870s, beginning in 1870 when a mixed jury of men and women were called to decide the fate of a man accused of manslaughter. It was the

first time in history that women had been subpoenaed for jury duty. Laramie built a brand-new courthouse in 1871, and in 1872, a territorial prison was built just west of the city limits. In 1875, the Colorado Fuel and Iron Company built a rolling mill to recycle scrap metal into railroad rails and machine parts.

During the 1880s, Laramie's growth began to slow a bit. In 1881, a new journalist named Edgar Wilson "Bill" Nye arrived in town. It wasn't long until he established a Laramie newspaper named the *Laramie Boomerang*, which is still published today. In 1882, Fort Sanders, south of town, a frontier military post since 1866, was decommissioned and closed. That same year, Laramie got its first telephone exchange, and soon any number of phones could be found in homes around town. In 1885, Laramie acquired a glass factory, which lasted less than 10 years. The University of Wyoming, with one building located right in the middle of a buffalo wallow, first opened its doors in 1887, with an enrollment of 42 students. The winter of 1886–1887 was a tough one for everybody concerned. Unrelenting snow and wind continually hammered the state. As a result, the loss of sheep and cattle that winter was monumental. Forever after, historians would refer to it as the year of the white death.

Somehow everybody muddled through, and suddenly the 20th century was here. On September 14, 1901, Teddy Roosevelt became president, setting the tone for an optimistic future. The university continued to grow, adding fraternities and sororities to the academic mix. The variety of university presidents down through the years can only be described as the good, the bad, and the short-lived. Beginning in the last quarter of the 19th century, Laramie became a whistle-stop for a number of U.S. presidents, including John Garfield, Teddy and Franklin Roosevelt, William Howard Taft, Harry Truman, and John F. Kennedy.

From the beginning, Laramie industries were major contributors. Through the years, Laramie had a rolling mill, two plaster mills, two stone quarries, and a creosote plant. The railroad had an ice storage plant, and stockyards were built nearby. The Great Depression, or "The Dirty Thirties," as it was sometimes called out West, hit Laramie just as hard as it did the rest of the country. That old song, "Hey Brother, Can You Spare a Dime," was on everybody's lips. It was the beginning of World War II before the country began to recover.

From the beginning, Laramie has had the lion's share of bordellos. But with the departure of the railroad repair shops and the changing mores of the American people, they all shut their doors for good by 1959.

As of the year 2006, Laramie has a population of around 28,000 and counting.

When an outsider thinks of Laramie, he or she usually thinks of the "Wild West"—desperadoes, gunfights, and cowboys, all larger than life, rushing to the rescue of fair maidens in distress and always arriving just in the nick of time. The "Western Myth" has become a part of Laramie's lore, and it helps us to identify the community as what it is today. As long as Laramie survives as a community, that myth will be alive and well.

So unsaddle Old Paint and put him in the barn. Then head to the house for supper. After a good meal, when the evening becomes quiet, stretch out on the couch, grab this little tale about Laramie, and read to your heart's content.

# *One*

# CARVING AN EXISTENCE ON THE HIGH PLAINS

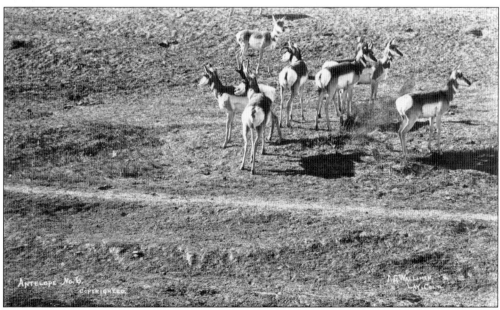

**PRONGHORNS ON THE PRAIRIE.** The zoologists call the pronghorn antelope *Antilocapra Americana*. It is found all over western America, from the Rio Grande in the south, to the Saskatchewan River in Canada, and from the Pacific Ocean, east to the Missouri River. The pronghorn antelope was just one of many animals that could be seen as the railroad pulled up to the end of the track in Laramie.

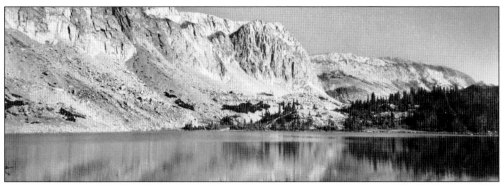

**LAKE MARIE.** Nestled in the Snowy Range Mountains west of Laramie, the lake sits at the bottom of a formidable granite outcropping called Medicine Bow Peak. Since 1879, it has been a garden spot for fishing, camping, hunting, and hiking for locals and tourists alike. Its namesake was Mary Bellamy, who became Wyoming's first female legislator in 1910. While in office, she worked tirelessly for the protection of children's and women's rights.

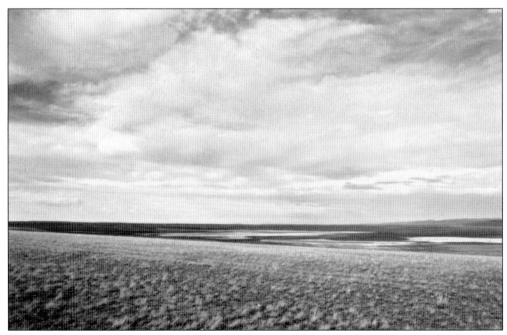

**ENDLESS PRAIRIE.** This was one of the vistas that greeted early settlers who arrived in Laramie. The vast openness of the high plains was so overwhelming that there were those who were heard to exclaim, "From here, you can see further and see less than any other place on earth!" No doubt about it, for some, that seemingly endless prairie was truly daunting.

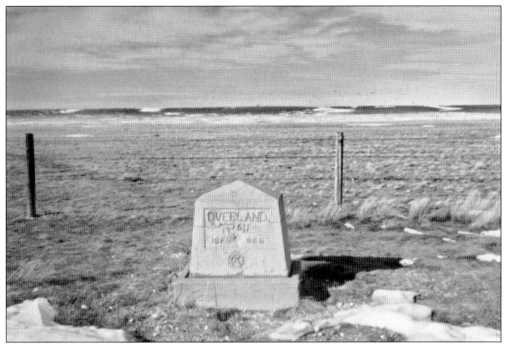

**MANY MILES TO CROSS.** The Overland Trail was first established in 1862. It stretched from St. Louis to California and ran all across southern Wyoming. Ben Holiday originated the trail in an attempt to avoid the Native Americans who continually plagued those crossing the Oregon Trail. One of the trail markers can be seen just a few miles west of Laramie.

**ALKALI FLATS.** A rancher was never happy when he discovered an outcropping of alkali on his ranch. It was very hard on cattle, sheep, and horses. As Sweet Betsy once sang, "A miner said, 'Betsy, will you dance with me?' 'I will that, old Hoss, if you don't make it too free. But don't dance me hard, do you know why? Doggone you, I'm chock full of strong alkali.'"

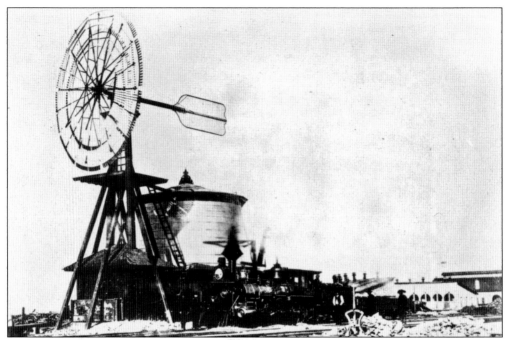

**WIND POWER ON THE PLAINS.** Steam engines always need water. After people tapped into the city springs, it was not long until a huge windmill and storage tank were built to provide that precious commodity. The railroad soon had machine shops made of stone brought in from Rock Creek and a 20-stall roundhouse to maintain and repair those engines.

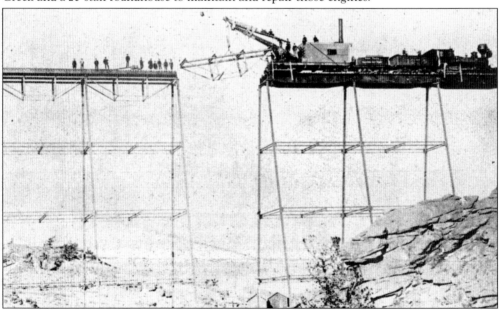

**A BIG BRIDGE, BUT VERY LITTLE WATER.** Located 20 miles east of Laramie, the Dale Creek Bridge may have been the highest railroad bridge in the world at that time. The first bridge, made completely out of wood, was completed in 1868 and brought the first trains into Laramie City. In 1877, it was replaced by a steel bridge (seen here) that would last until 1901. It was torn down when the railroad tracks were moved to a different location.

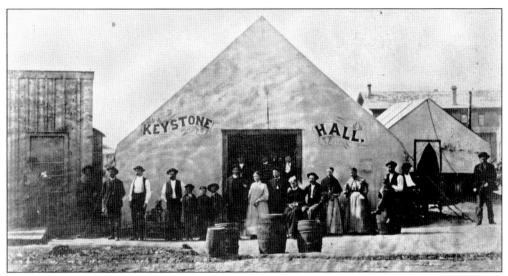

**AND THEY DANCED BY THE LIGHT OF THE MOON.** For the first few months of its existence, Laramie was a rough-and-tumble town. Keystone Hall was just one of several covered frame tents used to entice customers into an evening of gambling, beer, and whiskey, along with sampling the sensual delights of the available "ladies of the evening."

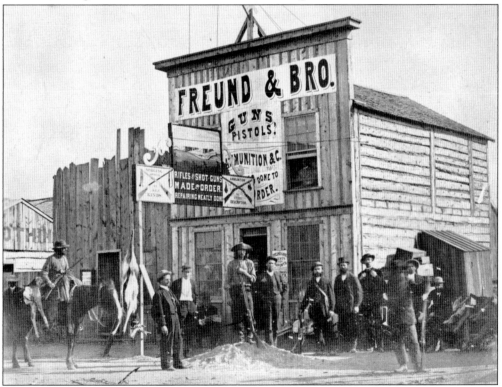

**THE WILD AND WOOLLY WEST.** In 1868, this store was located between First and Second Streets on what would become Ivinson Avenue. The gentlemen seen here were a true cross section of Laramie's citizens at that time. With the variety of goods that the proprietor had to sell, it makes a time-honored point that "the West wasn't won with a registered gun."

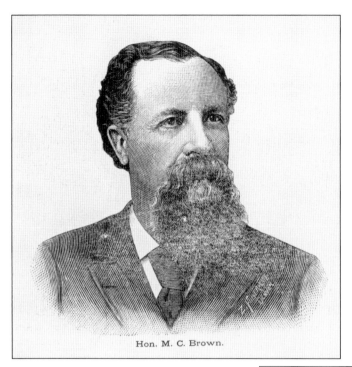

Hon. M. C. Brown.

**THE MAYOR RENEGES.**
Born in Maine in 1838,
Melville C. Brown came
to Cheyenne in 1867 and
began to practice law.
Then in 1868, he moved
to Laramie to become the
town's first mayor. After
three weeks in office,
he resigned, noting that
Laramie was hopeless with
all the lawlessness, garroting
of people, and bloodletting
that was going on.

**SEND FOR THE BOZ.** N. K. Boswell was
one of the lawmen who helped to bring
order and stability to the near-lawless town
of Laramie City during its first decade of
existence. Boswell had been a member
of the Rocky Mountain Detectives and
a former Cheyenne minuteman. Elected
sheriff and later defeated, he was appointed
town marshal and cleaned out the town's
riffraff, one by one.

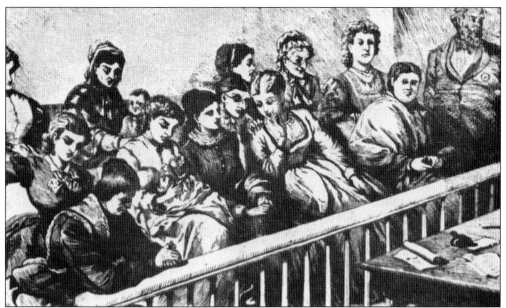

**LESLIE'S FOLDEROL.** It was the first time in the history of the United States that women were called to serve on a jury. The place was Laramie City, and the year was 1870. Journalists from all over the country showed up to see what it was all about. Eastern wags thought that it would probably be sort of a lark and just a one-time occurrence. An artist from *Leslie's Illustrated* depicted them (above) as an all female jury, which was certainly not true. While court was in session, each of the women was veiled to hide her identity. For those that disapproved, it was thought that those women would probably all have crying babies on their laps. One journalist even sarcastically hinted that the men and women would be confined to one bedroom. At the same time, William of Prussia sent President Grant a telegram with congratulations, stating ". . . upon the evidence of progress in America."

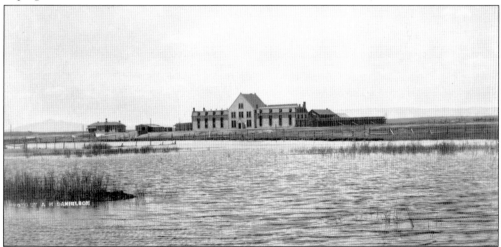

**BIG HOUSE ACROSS THE RIVER.** In 1872, a territorial prison began to take shape in Laramie. The Wyoming Territory now had enough population to warrant such a structure. Inmates were incarcerated there for a variety of reasons, from petty theft to murder crimes. The territorial prison would serve the state of Wyoming until June 1903, when inmates were transferred to a new facility in Rawlins.

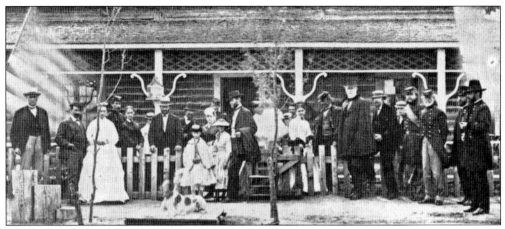

**A Social Gathering Out on the Prairie.** It was the summer of 1868, and Ulysses S. Grant was running for president of the United States. Shown with a cape draped over his arm, he joined other dignitaries out at Fort Sanders, south of Laramie, as they all conferred about what was to be done to finish building the Union Pacific Railroad.

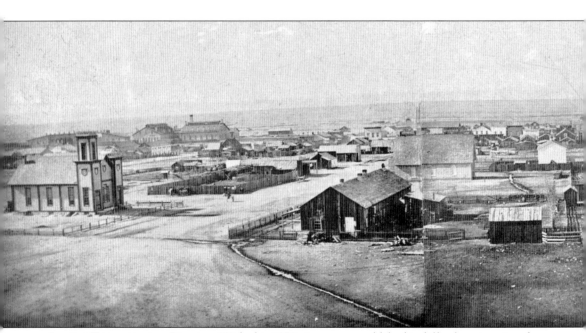

**Little Town on the Prairie.** With this 1870 view, one would find it difficult to imagine that Laramie would eventually become a thriving community of 28,000 people with a university enrollment of 11,000. Back then, Laramie's dirt streets, surrounding prairie, endless wind, harsh winters, and sparse population must have been extremely difficult to live with, to say the least. To quote Charles Dickens, "It was the best of times, it was the worst of times," which applied to the community that was just two years old. To be sure, there were the Ivinsons, the Browns,

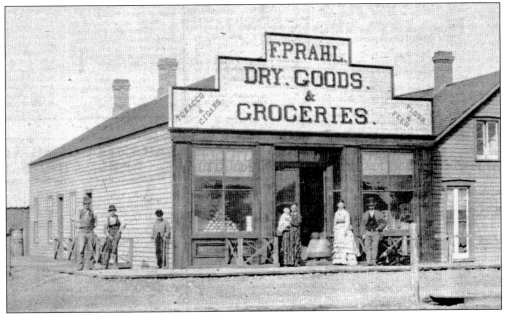

**FIND IT DOWN AT PRAHLS.** Arriving from Denmark in 1869, Frederick Prahl built this store in 1873. He specialized in dry goods, groceries, tobacco and cigars, and flour and feed and did a brisk business serving the community. The store was situated on the corner of Second Street and Kearney, where the Clure Brothers Furniture store is now located.

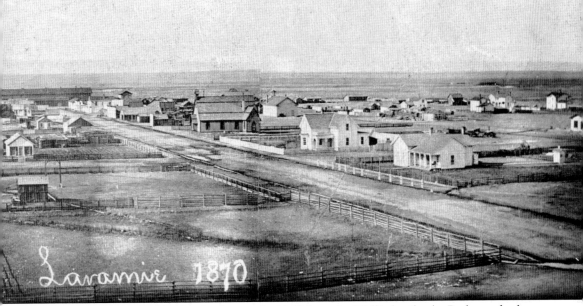

the Trabings, the Prahls, the Cordiners, the Hollidays, the Wallis family, the Baths, and others, all of whom arrived early to help the community grow. Not all was peaches and cream though. During the 1870s, before they were either sent packing or brought to justice, the likes of Jesse James, Calamity Jane, "Big Nose" George Perotte, and Dutch Charley did everything they could to make life miserable for the good folks of this community.

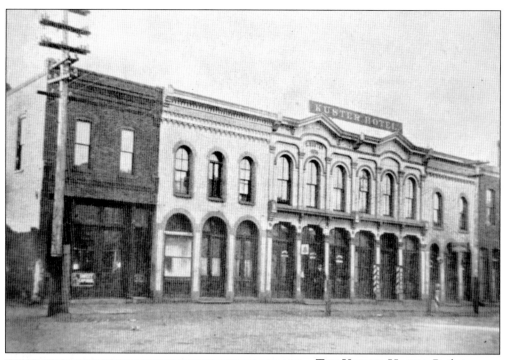

**THE KUSTER HOUSE.** Built in 1872, the Kuster House, also known as the Kuster Hotel, at 110 Thornburgh (Ivinson) Avenue was a well-known landmark in Laramie for many years. When the train depot burned down in 1917, the Kuster House served as a ticket office and waiting room until the Union Pacific built a new train depot at First Street and Kearney in 1924.

**AN OUTSTANDING BUSINESSMAN.** W. H. Holliday established his business in 1872, specializing in lumber and hardware, and later expanded into selling sewing machines, Willow Ware, pictures, doors, and building materials of all kinds. Holliday became extremely successful with the items he sold. He also took time out to serve in the Wyoming State Legislature.

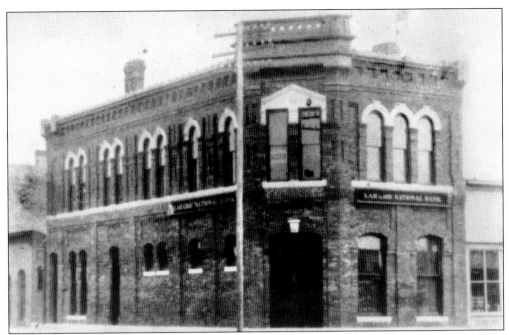

**BANK NOTES, COINS OF THE REALM, AND CREDIT.** Banking came early to Laramie. By 1871, there were two such financial institutions in town. The most prominent was the Laramie National Bank, which was located on the northeast corner of Second Street and Thornburgh (Ivinson) Avenue. In 1900, it became the First National Bank, with D. C. Bacon as president.

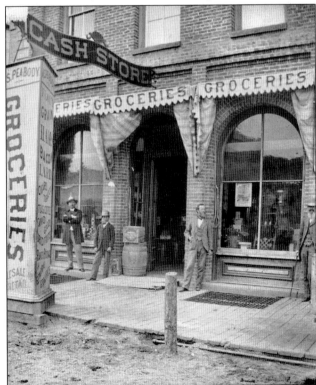

**PEABODY GROCERIES.** In 1878, A. S. Peabody established a grocery store at 207 South Second Street in Laramie. In 1898, W. H. Peabody became the store's manager. According to the *Laramie Republican*, both men were always careful to evenly match their prices with the quality of goods they sold.

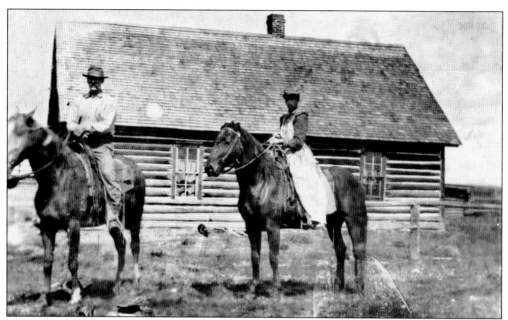

**SNUG AND WARM.** Out on a ranch in 1906, a typical house or cabin built of logs usually looked something like the one pictured here. When building a home, many would caulk the space between the logs with a type of plaster made of water, sand, and gypsum or lime. Once hardened, it was very effective and weatherproof. Out West, a woman was not required to ride a horse sidesaddle.

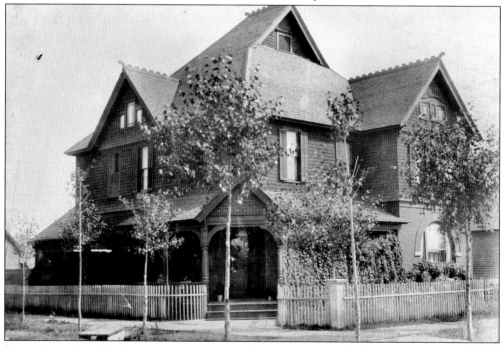

**SIMON SAYS.** In 1872, Simon Durlacher, a prominent clothier in Laramie, built this sumptuous home at 501 Custer. At the time, it was one of the prominent homes in the city. His place of business was located in the 200 block of South Second Street. The name Durlacher was placed across the cornice of the building and can still be seen today.

**A Marriage.** On May 15, 1871, Anna Rebecca Brownell House (1854–1913) was married to George Knadler at Fort Sanders, south of town. The Knadler family, which also included M. F. (who became a deputy sheriff) and Charles (who worked as a laborer), along with their descendants, would become prominent citizens of the community down through the years.

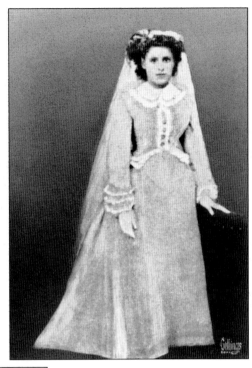

**IOOF.** There have been Independent Order of Odd Fellows members in Laramie since the town was created. The organization built this lodge in 1869 at 210½ South Third Street, used the second floor for their meetings, and rented the rest of the building. A split occurred in 1873, which created two lodges. Then in 1954, the Laramie Lodge joined the Albany Lodge to build a new meetinghouse at Twenty-first and Garfield Streets.

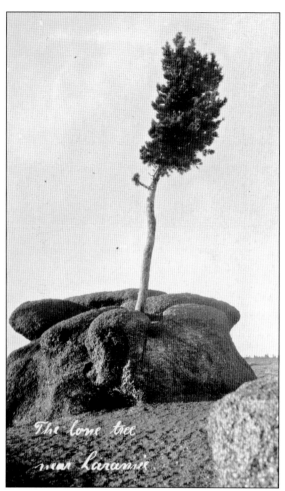

The lone tree near Laramie.

**CUT 'EM OFF AT THE PASS!** In 1865, while Grenville Dodge was surveying a route for the Union Pacific Railroad, Native Americans attacked him and his party. Riding hell-bent-for-election, they all galloped by this lone pine tree in a rock formation and into Cheyenne for safety. The railroaders watered this "tree in the rock" to encourage its survival, and it is now a tourist attraction located between Laramie and Cheyenne on I-80.

**CAMEL ROCK.** This one must feel a twinge of loneliness as he squats near Sand Creek a few miles southwest of Laramie. Even in the early days, this sandstone formation was called either Camel Rock Mountain or simply Camel Rock. Climbers using rope and pitons take great delight in scaling to the top for a quick look-see while lounging on the back of that camel.

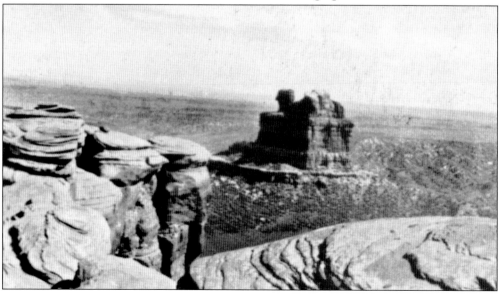

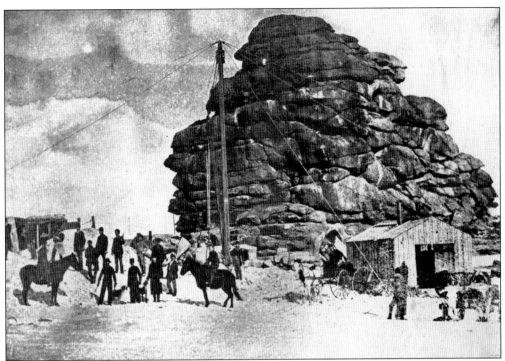

**OAKS AND OLLIE.** Oaks and Oliver Ames were the kingpins in getting the Union Pacific Railroad built. Seen here under construction, and located at the highest point on the railroad east of Laramie, a monument in the form of a pyramid was completed and dedicated to them in 1882. Some 65 feet tall at its peak, and costing about $65,000, it remains a tourist attraction today.

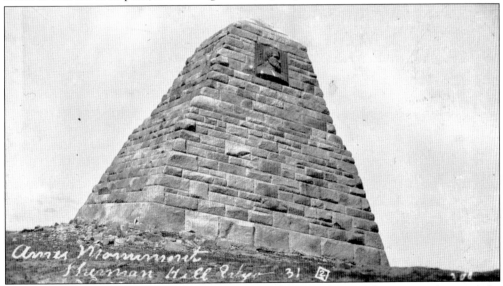

**A TWICE-OWNED MONUMENT.** Shortly after the completion of Ames Monument, a homesteader by the name of Murphy discovered that Ames Monument was actually constructed on public land. So he filed a claim on the land and told the railroad that they were to remove that monument forthwith. Much wrangling occurred between the two entities, and in the end, Murphy lost. The monument remains on its original site.

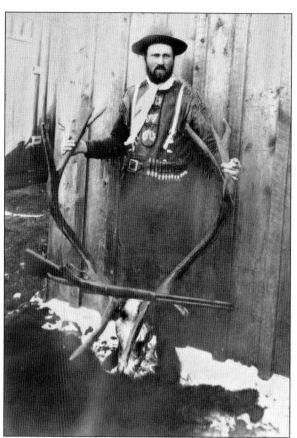

**THE ANTLERS OF THE WAPITI.** Here is an 1886 photograph of an unidentified hunter standing behind his trophy with a Winchester rifle nestled in the antlers of the elk. He is wearing a gun belt filled with shells, a white scarf, suspenders, and a shirt beaded on the front with fringe drooping over each shoulder.

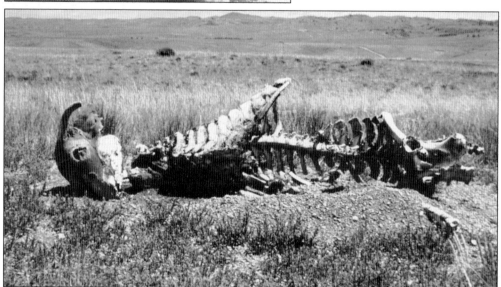

**DEATH ON THE PLAINS.** The year 1886 was a disastrous one economically for both the state of Wyoming and Laramie. The ranchers were particularly hard hit. The death of livestock was so great that it was called the "Year of the White Death." On those ranches surrounding Laramie, one could literally walk for miles by simply jumping from one dead carcass to another.

# Two

# RAILROADERS AND COWBOYS MARK THE TOWN'S GROWTH

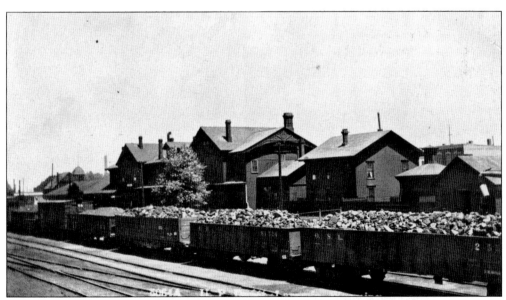

**A REGULAR STOP ON THE UNION PACIFIC.** Pictured at left, the railroad depot, including the restaurant and hotel, was built in 1868 and remodeled in 1900. The whole complex was a popular gathering place for both locals and travelers alike. Because it was a regular stop for the passenger trains, it was not long until Laramie, as a town, became well-known all across the country.

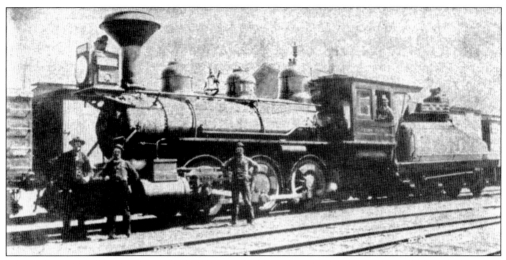

**SEE THE LITTLE PUFFER BELLIES.** Without a doubt, Laramie was a railroad town. Up until the second half of the 20th century, it was probably the biggest business in the city. But in order to run a steam engine, it needed coal and water, which the railroad's coal mines on the west and the water east of town readily gave.

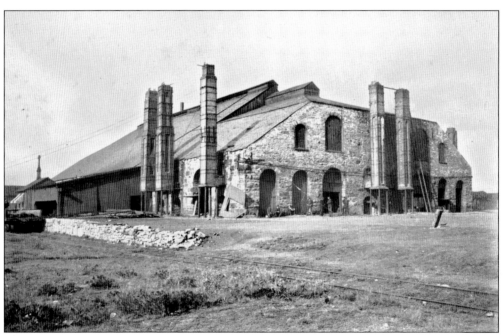

**PITTSBURGH OF THE WEST.** The city fathers hoped that this name would apply to Laramie after the construction of the Colorado Fuel and Iron Company's rolling mill in 1875. Here new rails and machine parts were manufactured for use all along the line. Unfortunately, the plant burned to the ground in 1910 and was never rebuilt.

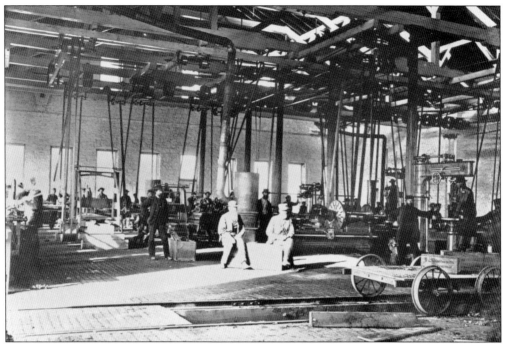

**KEEP THOSE TRAINS ROLLING.** Immediately after Laramie became a town, the Union Pacific machine shops were built to maintain and repair the railroad's cars and engines. With railroad tracks running through the building, it was much easier for the laborers to repair and maintain those engines, cars, and equipment.

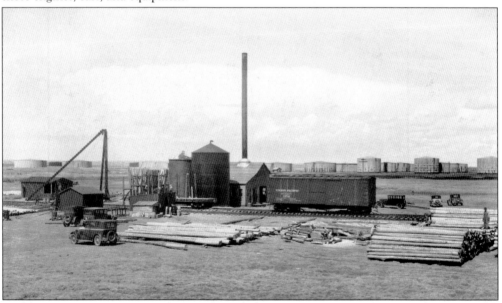

**AN ENVIRONMENTALIST'S NIGHTMARE.** In 1875, the Union Pacific Railroad established a crosstie treatment plant just south of Laramie, where each tie was covered with creosote to lengthen the life of the tie. The plant was in business until the mid-1990s when, through the efforts of the environmentalists, the plant finally closed down for good. The only treatment plant the Union Pacific has left is in the Dalles, Oregon.

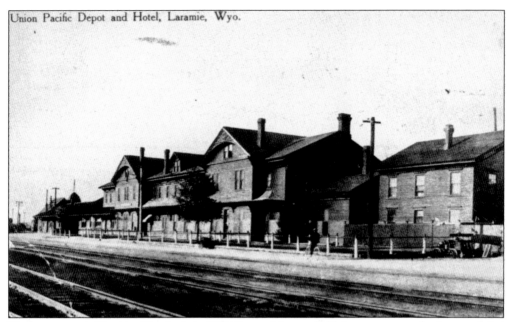

Union Pacific Depot and Hotel, Laramie, Wyo.

**VIEW FROM THE TRACKS.** First built in 1868, Laramie's grand old depot was completely remodeled around 1900. It included a fine hotel and restaurant where both the passengers and local citizenry liked to dine and enjoy themselves. Indoor plumbing was installed in that depot in 1885, some 16 years before the service would become available to the rest of the town.

**UNION PACIFIC HOSPITAL.** According to Matthew 9:12, "They that be whole need not a physician, but they that are sick." Built within the railroad yards between 1868 and 1870, the Union Pacific Hospital served its railroad employees until about 1876, when the Sisters of Charity opened a hospital out at Fifteenth Street and Grand Avenue.

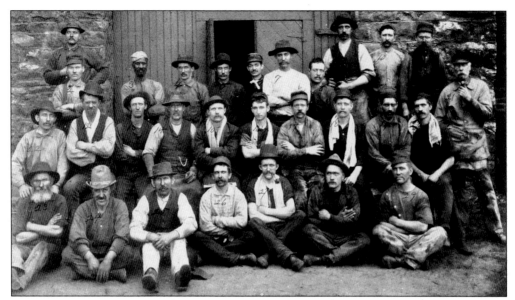

**THE WHOLE MOTLEY CREW.** From 1876 until 1910, when it burned to the ground, the Laramie Rolling Mills, which was operated by the Colorado Fuel and Iron Company and located within the railroad yards on the west side, did a bang-up job of turning out iron rails and machine parts. But this photograph of the men employed at that plant raises more questions than it answers. When was this photograph taken? What was the hourly, weekly, or even monthly wages of these men? How many hours each day did they work? Did they get Sundays off to attend church? Were any of them members of the old Knights of Labor, 1869, or the American Federation of Labor, 1886, both of which fought hard for the workingman's rights? Such questions are most vexing to the historian.

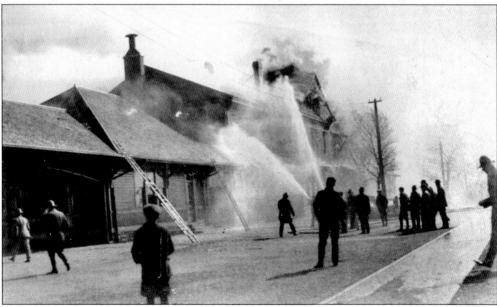

**A FIRE.** On October 17, 1917, Laramie's railroad depot, hotel, and restaurant caught fire and burned to the ground. At the time, there were no screens on any of the windows in the hotel, and a spark from one of the steam engines flew into an open window in a room on the second story and ignited the blaze.

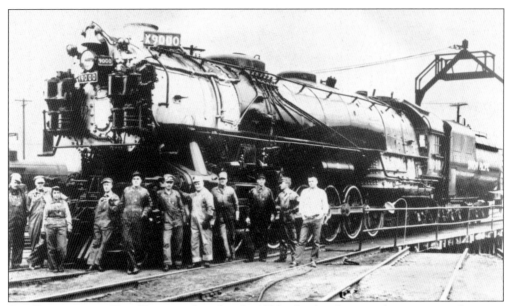

**THE ENDING OF AN ERA.** First introduced in the 1930s, the diesel-powered train engines began to replace those powered by steam. During the last run of Engine No. 9080, on April 27, 1956, standing from left to right are Beamen, Deaver, Sanchez (turntable operator), Melcher (machinist), Hittle (boilermaker helper), Taylor (engine cleaner), Grant (foreman), Howell, Trautwig (machinist), Johnson (machinist), and Magill (engine dispatcher). They all are saying farewell during that engine's last run.

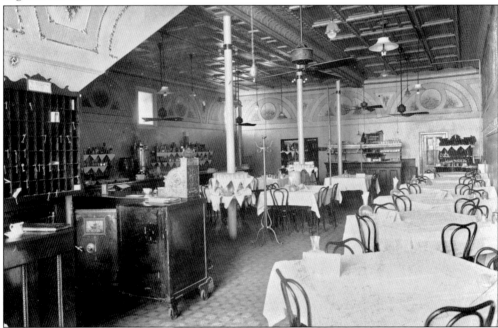

**WHERE THE ELITE MEET TO EAT.** Built in 1868 and remodeled in 1900, the Union Pacific Depot, along with adjoining hotel and restaurant, was noted for its frontier elegance. This 1910 view of the restaurant, with its fancy cash register, electric lights, and fans in the ceiling, shows that it was a most sociable place to dine.

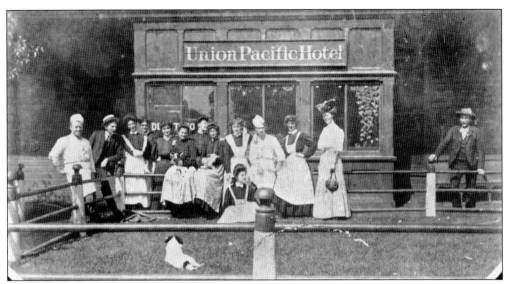

**LET'S ALL MEET AT THE HOTEL.** The Union Pacific Hotel at First Street and Thornburgh (Ivinson) Avenue was a favorite place for employment in 1905. Photographed from left to right are two unidentified, Annie Piper, four unidentified, Hild Lehman, Annie Pilger, two unidentified, Lizzie George Krueger, Birdie McSweeney, and Mr. Cook (reporter for the paper); Mr. Cook's dog sits in front. Why they all posed for a photograph at that time is unknown.

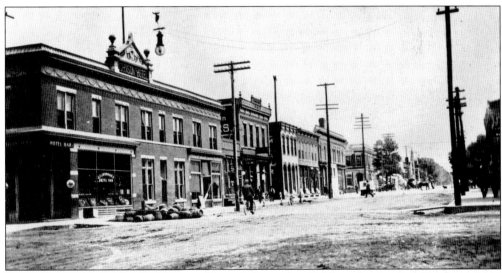

**THE NORTH SIDE OF GRAND AVENUE.** The only thing identifiable in the photograph, taken around 1900 looking east on Grand Avenue, is the Johnson Hotel at left, which was built that same year. Also shown is a boy riding a bicycle, two men strolling down the sidewalk, and a man crossing the street with a horse and buggy in the background. Note the electric poles in the street.

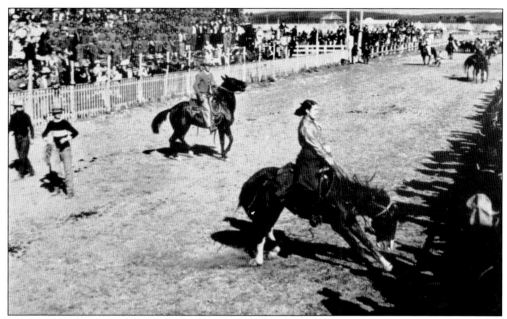

**LET 'ER BUCK.** It would seem as if women's lib was alive and well during the 1908 Fourth of July celebration at the Albany County fairgrounds. After a parade that marched east on Grand Avenue to the fairgrounds at Eighteenth Street, a rip-snortin' rodeo was held for the enjoyment of all. Soldiers from Fort D. A. Russell in Cheyenne were among those in the grandstands enjoying the festivities.

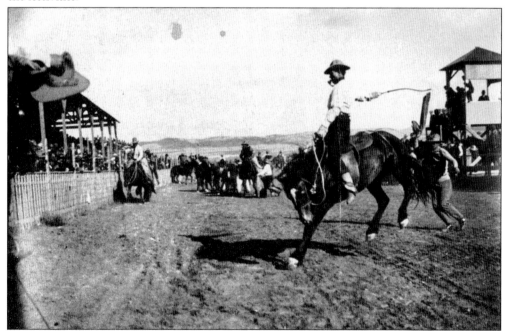

**A LARAMIE FOURTH OF JULY.** A cowpoke on a bucking horse is part of what a rodeo is all about. If he can ride the bronc for eight seconds, he has a chance of walking away with some good prize money. This was the summer of 1908, and by the looks of it, everybody was having a great time, including the cowboy!

**BUT DARLIN' IT'S COLD OUTSIDE.** Winter life on a ranch on the western plains wasn't all that easy. It must have been around the end of the 19th century when Mr. and Mrs. Sodergreen, all decked out in their overcoats made of beaver, posed for this photograph in front of their Albany County ranch home.

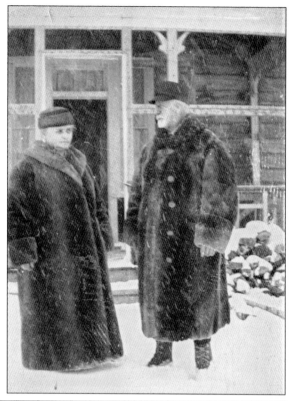

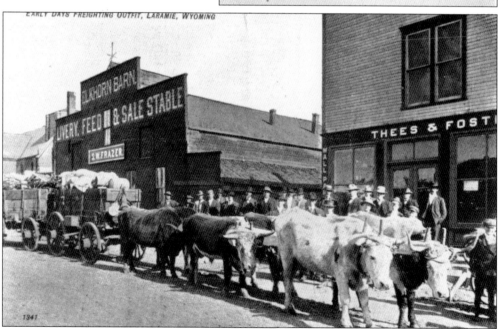

**HAULIN' FREIGHT.** Located on the corner of Third Street and Thornburgh (Ivinson) Avenue 24 years before the 20th century, the Elkhorn Barn and Livery Stable was one of the prominent businesses in Laramie. It was here that Jack McCall, a fugitive from justice, was arrested for shooting Wild Bill Hickok in the back, in Deadwood, South Dakota, in 1876.

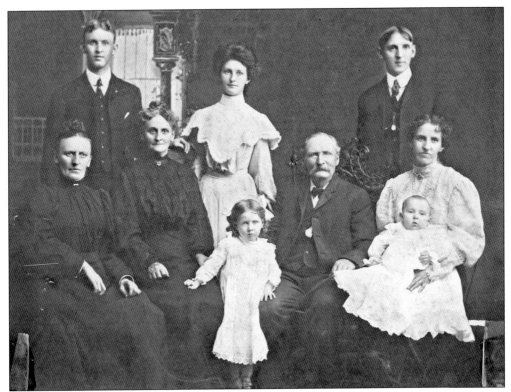

**END-OF-THE-19TH-CENTURY TINTYPE POSE.** The Prahls were a pioneer family who arrived very early in Laramie, and some of their descendants have lived here ever since. Pictured here are, from left to right, (first row) Freda, Cristina, Henrietta, Fred, and Carrie, holding Kenneth; (second row) Harry, Clara, and John. Henrietta and Kenneth are Carrie's children.

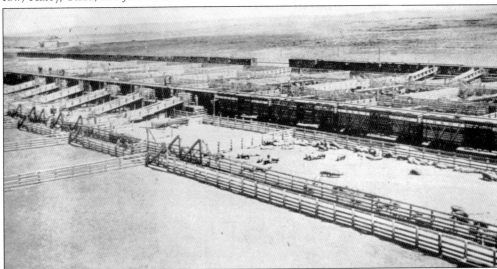

**THEY'VE GOT TO BE FED AND WATERED.** Originally the stockyards were located along the railroad tracks north of the present-day depot. About 1910, they were moved to the north end of Laramie, as seen here. It was at this location that all of the livestock that came through town were taken off the train, fed and watered, loaded back on the train, and sent on their way.

**SUCH ELEGANT DRESS.** Is it a dress, a frock, or a gown? Whichever it is, it is quite beautiful. This photograph of Christina Prahl was taken during the last quarter of the 19th century, very likely the 1870s. Unfortunately, other than her name on this photograph, absolutely nothing else is known.

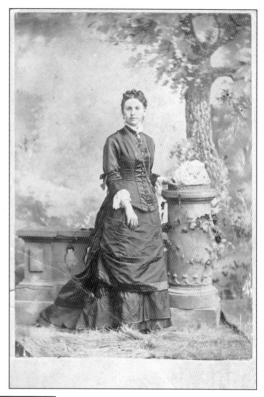

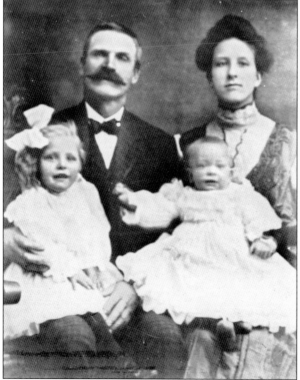

**A WYOMING RANCH FAMILY.** One of the more prosperous ranchers in 1909, Fred Bath, along with his wife, Vallie, and children Vallie and Carl, opted for the ranch way of life. Their ranch was located about 12 miles northwest of Laramie. Bath was one of the few ranchers in Albany County who had his home built out of stone blocks, quarried east of town.

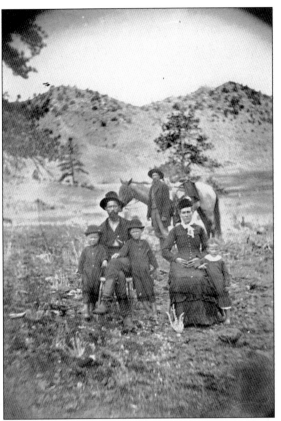

**EARLY SETTLERS.** Oh, what an unromantic view this is of the great American West! Unfortunately, no one knows the year it was taken or the names of Mom, Pop, the three children, and perhaps Grandpa standing in front of his horse. Although it could be anywhere, the hills behind them resemble those of the Sybille Country, northeast of Laramie.

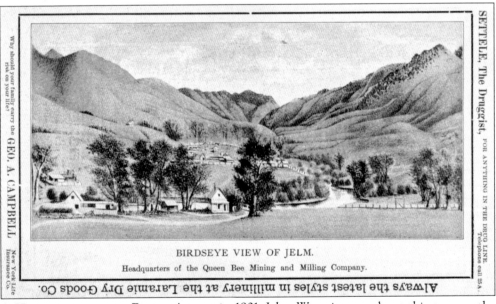

Why should your family carry the GEO. A. CAMPBELL New York Life Insurance Co.

SETTELE, The Druggist, FOR ANYTHING IN THE DRUG LINE. Telephone call 25A.

BIRDSEYE VIEW OF JELM.
Headquarters of the Queen Bee Mining and Milling Company.

Always the latest styles in millinery at the Laramie Dry Goods Co.

**A HAMLET ALONG THE RIVER.** As seen in 1901, Jelm, Wyoming, was located just across the river from Woods Landing, both of which were about 30 miles west of Laramie. Jelm may have been a corruption of E. C. Gillem's name, a man who furnished ties for the railroad, or from the Scandinavian miners, who called the town Hjelm. Nobody knows for sure.

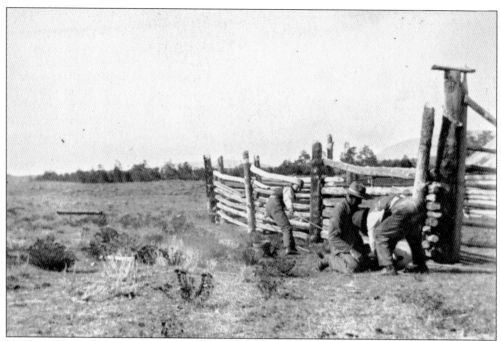

**THEN AS NOW.** Since the earliest days of cattle ranching, the castrating of the male calves, as seen here, has been used as a means to control the herd size. Also, a castrated calf will weigh more at sale time, and if there are too many males, they continually fight with each other in an attempt to dominate the herd.

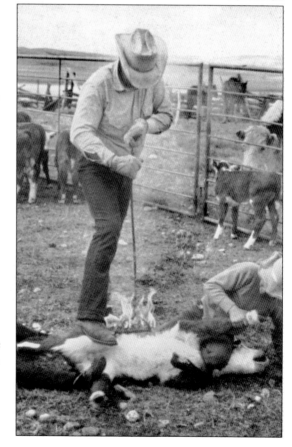

**BRAND 'EM WHILE THE IRON IS HOT.** Although the method of branding is slowly beginning to change from the use of a hot iron to under-the-hide implants, branding has been with the rancher since the days of the early Spanish explorers. Here Billy Dalles brands a white-faced Hereford on his Albany County ranch in 1973.

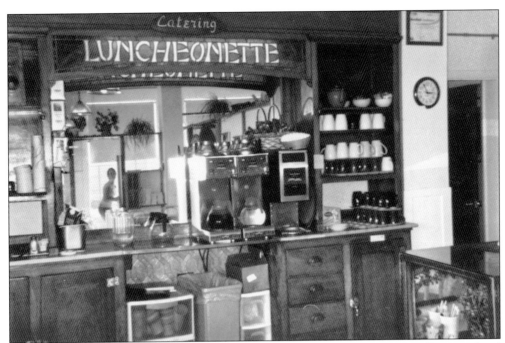

**A Railroader's Hangout.** From 1934 until 1968, Bill Lawrence and George Miller owned and operated the M and L Cigar Store on the southwest corner of First Street and Ivinson Avenue. The store included a lunch counter with the "luncheonette" backdrop seen here. Today that backdrop is still a part of the Overland Restaurant, which is located in the same building.

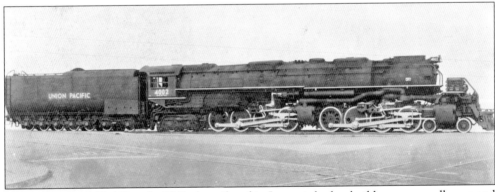

**Union Pacific's Big Boy.** In 1941, the railroad in Laramie had to build a new roundhouse and turntable to repair and maintain both the 3900 and 4000 Class steam engines. The 3900s, called Challengers, hauled passengers, while the 4000s, called Big Boys, hauled freight. They were all kept busy until the late 1950s, when the diesel-powered engines replaced those operated by steam.

# Three

# MEN, WOMEN, AND PLACES THAT DEFINED THE WEST

**A LARAMIE SCHOOLMARM.** The town's first school opened its doors in 1869 and was located about where the Connor Hotel is today. Although she was not the very first, Edith McLeod was one of Laramie's early schoolteachers. At the time, the going rate of pay for a teacher was between $50 and $75 a month, quite enough for a woman who was restricted in her socializing.

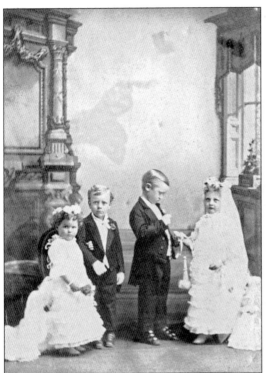

**A Mock Wedding.** From left to right, Addie Brown, Dick Spaulding, Ned Fitch, and Mattie Haley (age three or four) were all dressed up as bride, groom, and attendants for some sort of a program. It is estimated that this photograph was taken in the 1890s.

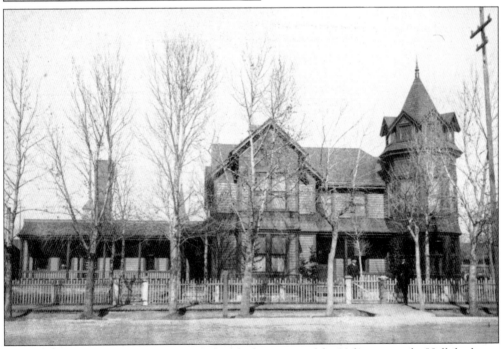

**Life in a Mansion.** When it was built, before the beginning of the 20th century, the Holliday home at 321 Garfield Street was nothing short of elegant. The story is told that William Jennings Bryan, who was running for president in 1896, spent the night at the Holliday home before continuing his 18,000-mile whirlwind tour around the country in his race for the White House.

**THE VICTORIAN AGE.** Standing in front of Settele's Drug Store at 218 South Second Street, and dressed to the nines, an unidentified gentleman and two ladies pause in their afternoon shopping. As Sir Edmund Gosse (1849–1928) wrote, "The Victorians carried their admiration to the highest pitch. They turned it from a virtue into a religion, and called it Hero Worship."

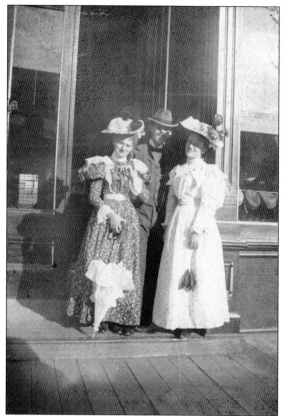

**A GARDEN PARTY.** It was 1894, and Edward and Jane Ivinson were now comfortably ensconced in their new home at 603 Thornburgh (Ivinson) Avenue. Although Edward tended to be somewhat of a penny pincher, when the occasion arose, he and Jane both relished in entertaining at their extraordinary estate. Though neither is in this photograph, the Ivinsons obviously allowed a special summer gathering to be held on the property.

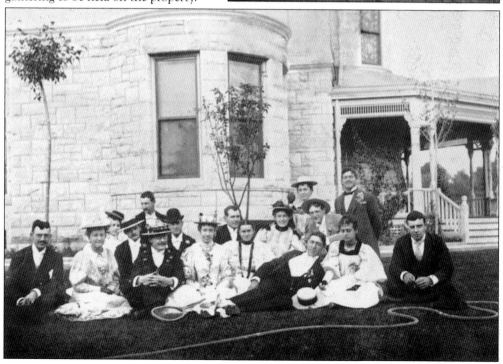

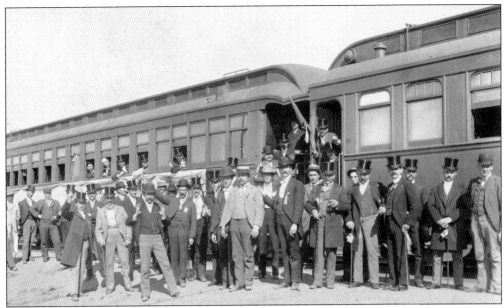

**THE ELKS TAKE A HOLIDAY.** It was around 1890 when these members of the Elks Club got ready to board a train headed for a get-together in Denver. It is interesting to note that some of them were all suited up with top hats and cutaway frocks while the others just wore their regular Sunday clothes.

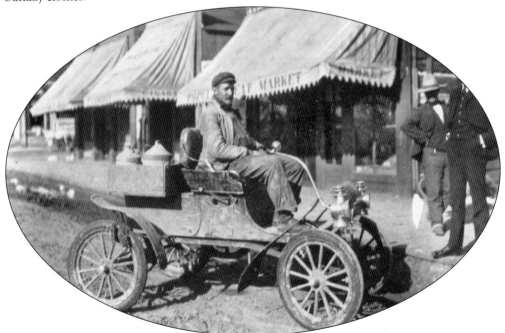

**JUST ANOTHER TIN LIZZIE.** Elmer Lovejoy was one of Laramie's early mechanical geniuses. At his Novelty Works located at 412 South Second Street in Laramie, Elmer not only repaired and maintained automobiles, but he also had a camera store and sold Crescent bicycles. During the New York–to–Paris auto race in 1908, Elmer gave a helping hand to the American entry when it came through town.

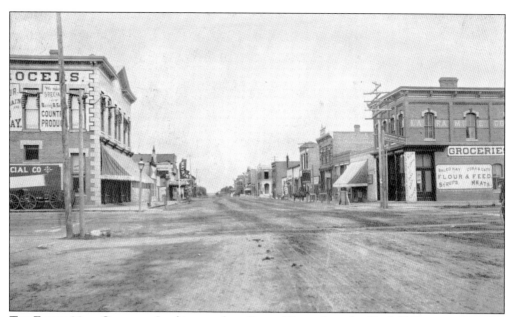

**THE EARLY 20TH CENTURY.** Looking north on Second Street from the Garfield Street intersection, it appears that there was no shortage of grocery stores. The Laramie Grocery Company is on the immediate left, facing the Trabing's Commercial Company. In either establishment, a $5 bill could give a customer more groceries than he or she could begin to carry out in a large paper sack.

**BUCKS, EWES, AND LAMBS.** It was during the 1870s that sheep first began to wander in Wyoming, and it wasn't long before sheep men could be found all over the state, some becoming quite wealthy. Such was the case of three brothers from England who immigrated to Wyoming at the end of the 19th century. Pictured are, from left to right, Francis, Herbert, and Joseph King. Through homesteading and the purchase of surrounding land, it wasn't long until they parlayed their holdings into 103 sections of land. Located about 8 miles north of town, their sections ran from the railroad tracks east over the Laramie Range. Before their retirement, they became world famous for raising and showing first the Rambouillet and later the Columbia breeds of sheep.

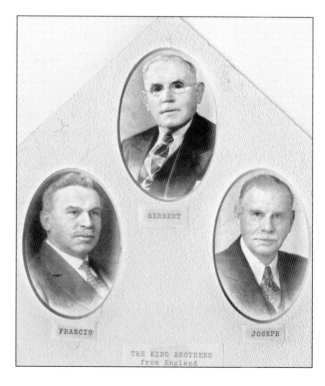

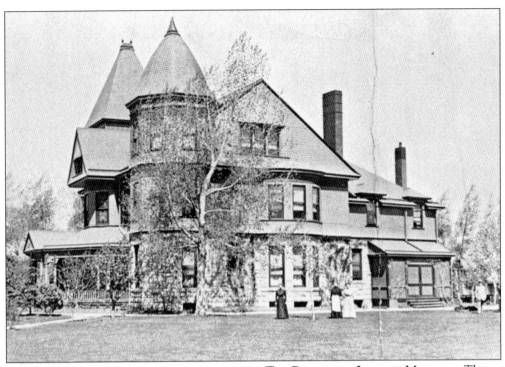

**THE BEAUTIFUL IVINSON MANSION.** The Edward and Jane Ivinson home, a real showpiece of the community, was completed in 1892. When Jane died in 1915, Edward kept the property until he donated it to the Episcopal Church in 1921. Today the mansion is the home of the Laramie Plains Museum.

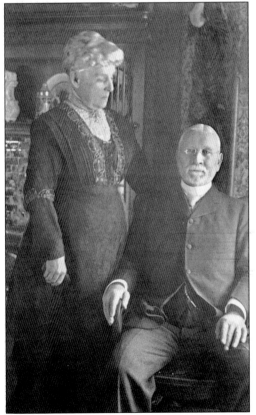

**LARAMIE'S GRAND COUPLE.** Jane Ivinson (1840–1915) and her husband, Edward (1830–1928) were both foreign born—he on the island of St. Croix in the Danish Virgin Islands and she in England. Both of them became U.S. citizens before they ever came to Laramie. This 1905 formal portrait of them was taken at their home at 603 Thornburgh (Ivinson) Avenue.

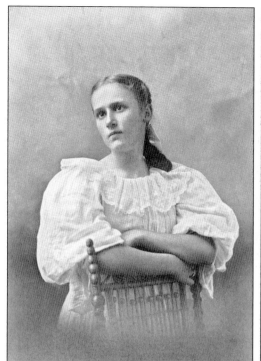
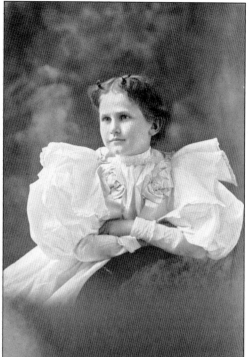

**IVINSON'S GRANDDAUGHTERS.** It was the gilded age, and Edward Ivinson's granddaughters all looked the part. Prim, proper, and so elegantly dressed, it is no doubt that all three of them broke the hearts of any number of would-be suitors. Pictured here clockwise from top left are Helen Jean (born 1879), Mary Elizabeth ("Libus") (born 1888), and Frances Adele ("Fannie") (born 1883).

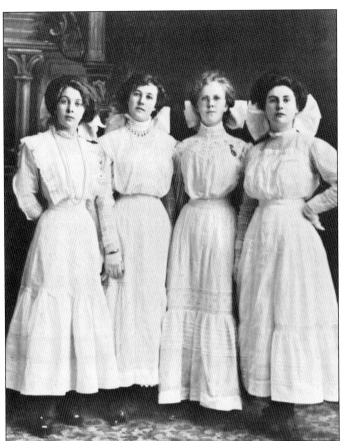

**A GRADUATING CLASS.** The year was 1910 and photographed from left to right are Lora Friday, Edith Hinds, Elsie Lester, and Katherine Hoge, listed as "Laramie school graduation class." It wasn't until 1911 that Laramie High School held its first graduation ceremony. Until then, Laramie High only went through 10th grade.

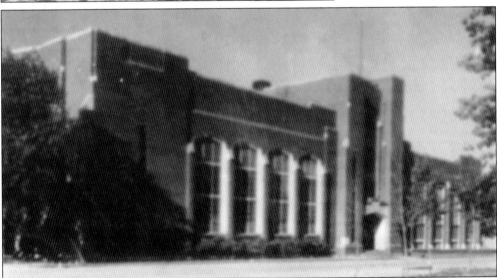

**LARAMIE HIGH.** Although there has been a high school in Laramie since 1869, this building was constructed in 1930. Laramie was a growing community, and in 1939, more classrooms and another gym were added to the building. It was used as a junior-senior high school until 1960, when a new high school was built on North Eleventh Street.

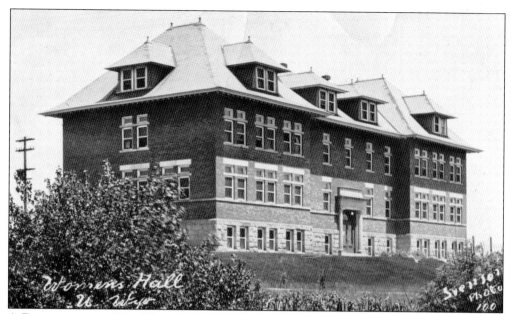

**A BUILDING WITH TWO NAMES.** When it was first built in 1907–1908, it was called Women's Hall and the domestic science department was housed in it, along with a girls' dorm. In 1922, it was renamed Merica Hall, after Charles Merica, who had been president of the university from 1908 to 1912.

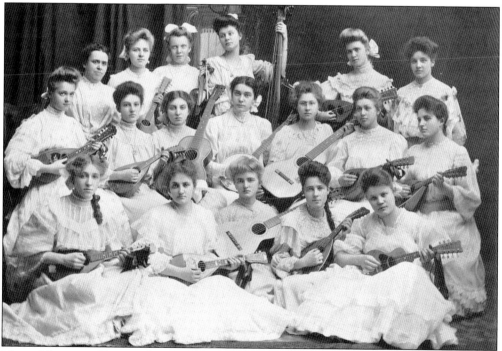

**MUSIC MAESTRO, PLEASE.** It was 1906, and the University of Wyoming was 20 years old. Even then, the Music Department was doing its bit to further the education of its students. Directed by Mrs. Justus Soulé, the Glee and Mandolin Club, all dressed in white, put on a number of performances for the student body that year.

First United Methodist Church
Laramie, Wyoming
History

1870 - 1904

1904 - 1959

1968

**Constructing Churches.** The first Methodist church, located on the southeast corner of Second Street and University, opened its doors to the faithful in December 1870. It was presided over by the Reverend George H. Adams. In 1905, a new church was built and completed by the W. H. Holliday Construction Firm, on the corner of Fifth Street and Thornburgh (Ivinson) Avenue, with Rev. Frank Boss as its pastor. Between 1921 and 1922, the Wesley Foundation was organized, and it wasn't long until they began holding their meetings in a building that had been brought in from Fort Sanders, south of town. Seeing the need for expansion, a new church was built at a total cost of $241,994 at 1215 East Gibbon Street in 1968. With its unusual design and Walcher organ, the church is now one of Laramie's most outstanding landmarks.

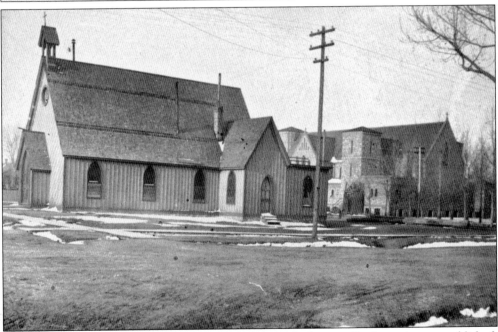

**A Moveable Church.** This little Episcopal church was built soon after Laramie was established. When the Episcopalians completed their cathedral in 1896, it was moved to the opposite corner. Just before Hunter Hall was built in 1925, it was moved to Rock River, Wyoming, north of Laramie.

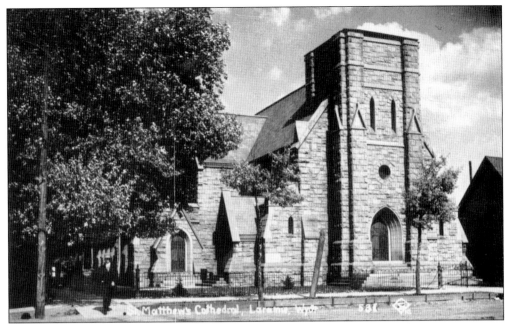

**WHERE'S THE STEEPLE?** St. Matthew's Episcopal Cathedral was built on the northeast corner of Third Street and Thornburgh Avenue, between 1892 and 1896. The new church replaced a wooden building that was constructed soon after Laramie became a town. The steeple and clock would not be added to the building until 1917–1918.

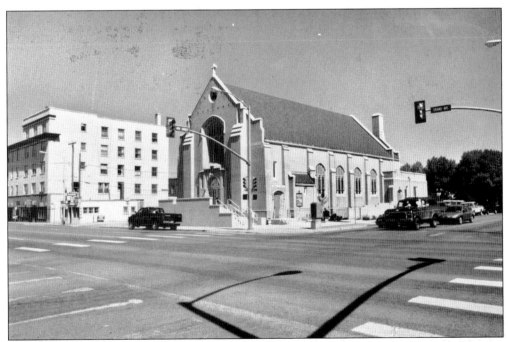

**SAINTS PRESERVE US.** Since the very beginning, churches have been a part of Laramie's history. Under the direction of Fr. John T. Nicholson, St. Laurence O'Toole's Catholic Church was dedicated in 1926. It replaced an older church that was built soon after Laramie became a town.

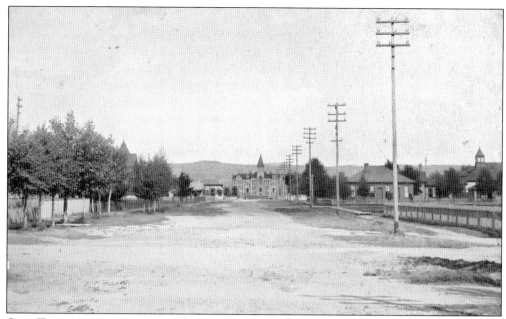

**COW TOWN WITH A COLLEGE.** This is probably the best way to describe Laramie in 1892, as one looked east on Center Street (soon to be called University Avenue). Photographed here is the University of Wyoming's Hall of Languages at the far end of the street, with a smattering of buildings here and there. Dirt streets, power lines in a row, and a growth of young trees complete the photograph.

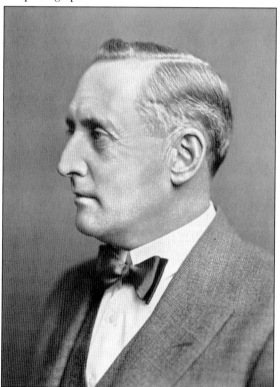

**ARTHUR GRISWOLD CRANE.** Although the student body at the University of Wyoming didn't have much affection for Arthur Griswold Crane, president of the university from 1922 to 1941, they did respect him. When first coming to Laramie, he drove from Cheyenne by motorcar. Some 12 miles east of town, a group of college kids driving a horse-drawn stagecoach kidnapped him and brought him into town to give him a grand and glorious welcome. He saw no humor in the antics at all. Although he was always somewhat standoffish with the faculty, he did much to help the university grow, even during those dark days of the Great Depression. In 1946, when no longer the university president, he was elected Wyoming's secretary of state, and in 1949, he automatically became governor, finishing out Lester C. Hunt's term after Hunt was elected to the U.S. Senate.

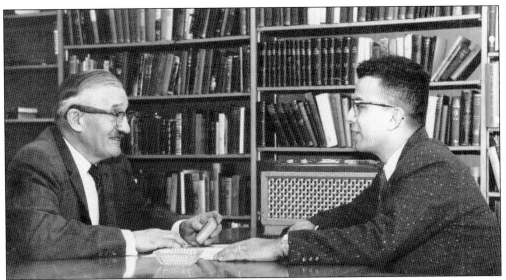

**WYOMING'S MR. GEOLOGY.** Photographed here from left to right are Sam Knight (1893–1975) and Gene Gressley. During his entire career, Knight was a geology professor at the University of Wyoming. He became world famous in 1925 after opening a summer geology camp located up on the Snowy Range, west of Laramie. In 2001, the State of Wyoming granted him the title of "Wyoming's Man of the Century."

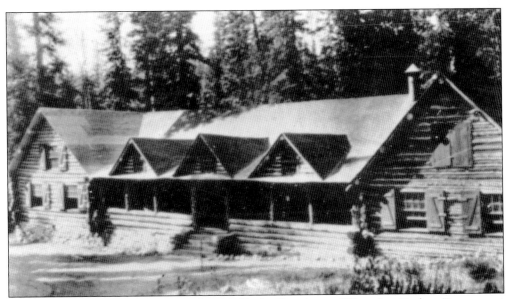

**HOME ON THE RANGE.** Between 1925 and 1973, the University of Wyoming Geology Department held summer science camps every year. Headquartered at this lodge, its purpose was to educate budding geologists on the flora, fauna, and geology of the Snowy Range Mountains, west of Laramie. At a rate of between 60 and 70 a year, students came from all over the country to participate in those camps.

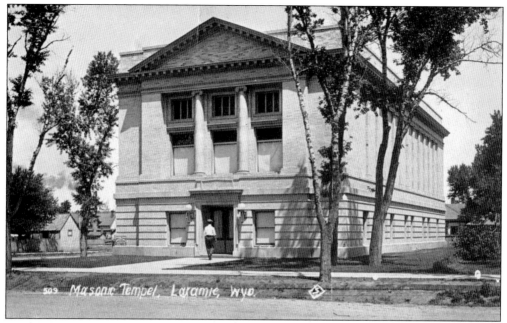

**LARAMIE LODGE NO. 3, ANCIENT FREE AND ACCEPTED MASONS.** The Ancient Free and Accepted Masons have been a part of Laramie's history since 1869. After they moved from one meeting place to another over the years, a permanent lodge was constructed and dedicated on June 24, 1912. The Masonic Lodge has used this building continuously ever since.

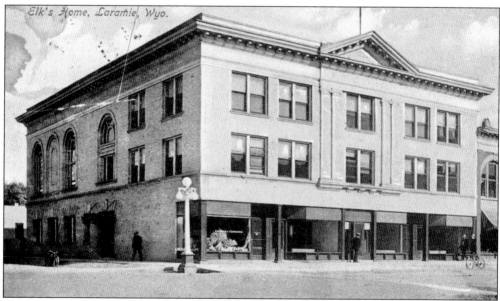

**THE ELKS CLUB.** Located on the northeast corner of Second Street and University Avenue, the Elks Club built a new facility in 1912. It replaced the old clubhouse, which was located diagonally across the street from the new building. The club even held a parade to help dedicate the new lodge. The club is still in use today, although the interior of the building has been completely renovated.

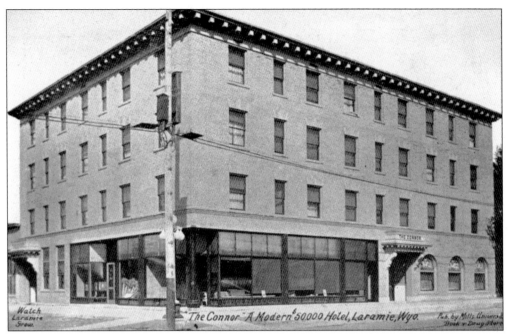

**MEET ME AT THE CONNOR.** Built in 1913, the Connor Hotel was the hub of downtown activity. Over the years, such businesses as the Connor Bar and Lounge, a coffee shop and restaurant, and the Greyhound Bus Depot were located there. Also included was a flower shop, a store for children's clothing, and a barbershop, as well as many others. The lobby even had a Bigelow's Stand that sold cigars, cigarettes, candy, and knickknacks.

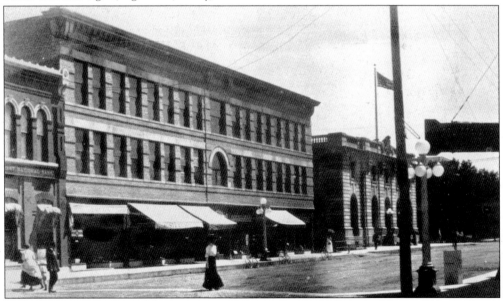

**KATE AND JESSIE.** Around the beginning of the 20th century, Kate and Jessie Converse had a three-story building constructed between Second Street and Third Street, right next to the First National Bank, on the north side of Thornburgh (Ivinson) Avenue. The bottom floor was filled with shops of one sort or another, while the other two floors housed a variety of offices. This photograph, taken in 1915, shows Laramie's post office at the far end of the block.

**AN IRISH WEDDING.** On September 10, 1913, Joseph Madigan married Dona Sterzbach at the first St. Laurence O'Toole Catholic Church in Laramie. After working as an accountant for various companies, Madigan went into business for himself in 1938, while Dona gained a great deal of notoriety as a pen-and-ink artist. The couple built a home at 1203 Garfield Street in 1920.

**LARAMIE'S FAIR LADY.** Marie (Montabe) Horton became one of Laramie's leading socialites. Married to Doc Horton, a well-known chiropractor, the couple made their home at 710 Grand Avenue. Marie wrote and produced a pageant called *The Wedding of the Waters*, which was performed annually for a number of years up in the Wind River Canyon, outside of Thermopolis. She died in the early 1970s.

**A FASHIONABLE LADY.** It was 1917, the year that the United States first became involved in World War I, and slowly but surely, women's clothing styles were beginning to change. Suddenly a well-dressed lady, such as Ethel Ernest, could show her ankles in an evening dress. No longer did the bodice of her dress have to run halfway up her neck for her to be properly dressed.

**GARRETT PORTRAIT.** Dressed in a white dress with an embroidered inset on the front bodice and wearing pince-nez glasses, a high collar, and large brooch, her hair piled up on her head, Mary A. Bonner Garrett (1863–1925) had the appearance of a lovely matron as she posed for this 1925 photograph.

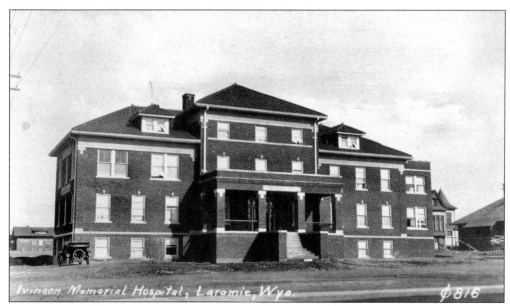

**IVINSON MEMORIAL HOSPITAL.** On June 7, 1916, Ivinson Memorial hospital opened for business. Dedicated to his late wife, Jane, Ivinson had given four city lots and $50,000 for the construction of that hospital on the corner of Tenth Street and Thornburgh (Ivinson) Avenue. Along with that, William Robertson Coe donated $3,965, which allowed the hospital board to purchase a brand-new Studebaker ambulance.

**WOMEN IN WHITE.** From 1924 until 1950, this building on the corner of Tenth Street and Ivinson was a rooming house for those single nurses who worked at the Ivinson Memorial Hospital. Most of the bedrooms were located on the second floor, while a large, comfortably furnished room on the ground floor was used as a parlor for those who wished to visit the nurses.

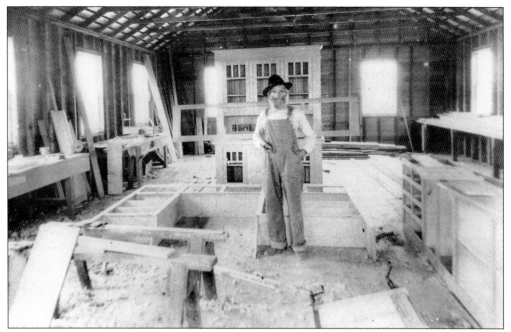

**SPIEGELBERG LUMBER.** In 1918, Frank Louis Spiegelberg established his lumber business on the west side of town. It wasn't long until his two sons William and Walt joined the company. As soon as they were old enough, siblings George and Hanna, who became head bookkeeper, also joined their father's company. The Spiegelberg Company is still in business today.

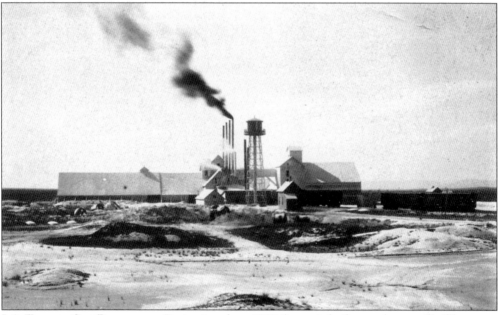

**IT'S TIME TO GET PLASTERED.** Beginning about 1920, Laramie built two plaster mills. They were located at the south end of town, and they had a miniature railway that ran from Second Street east to about Fifteenth Street. The train hauled the gypsum found there to one of the mills where it was processed into plaster. By the late 1920s, only this plant remained, and it finally closed its doors for good in the early 1950s.

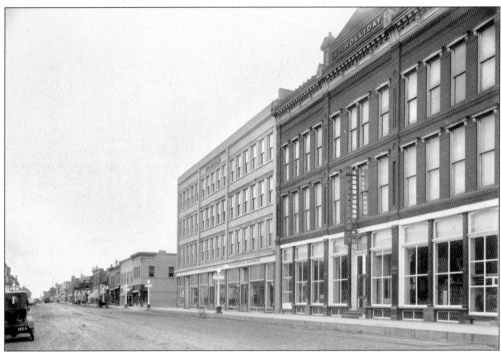

**SECOND STREET NEVER LOOKED BETTER.** While it lasted, Holliday's was one of the biggest businesses in Laramie. This building on Second Street between Custer and Garfield Streets, along with their warehouse, covering the other half of the block along Third Street, created a complex that covered half a city block. This gave physical proof of the large extent of their enterprise.

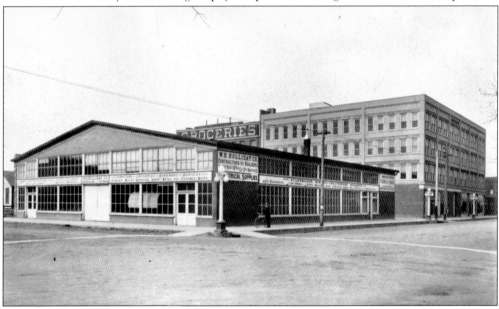

**HOLLIDAY'S WAREHOUSE.** Standing on the corner where the Bank of the West is now located, this building would see some changes over the years. By the 1940s, there were several stores facing the right on Garfield Street. Long since gone are the old-time streetlamps, which were reminiscent of those used by pawnbrokers when advertising their place of business.

**AND IT ALL WENT UP IN FLAMES.** From 1924 to 1948, the Raab Garage, located on the northwest corner of Third Street and Garfield Street, was the Chrysler Plymouth Agency for Laramie. Cornelius Raab, a German immigrant, was well-known and liked in the community and did a good business over the years. However, on April 14, 1948, the Holliday fire completely destroyed his building. Laramie businessman Jack Wagner had a half-dozen antique cars stored on the second floor of that garage, all of which were lost in the fire. At the time, Raab displayed a brand-new 1948 lime-green convertible with wooden door panels called the "Town and Country" in his showroom. Like everything else, it too went up in flames. Without a doubt, that fire was the worst in Laramie's history.

**A FIRE CAUGHT IN TIME.** On April 16, 1946, the Elks Club in Laramie caught fire. Most of the inside of the building was destroyed, as was most of the roof. Luckily, the fire department was able to extinguish the blaze before the building was completely destroyed. However, it took a great deal of repairing and remodeling before the structure was ready for use again.

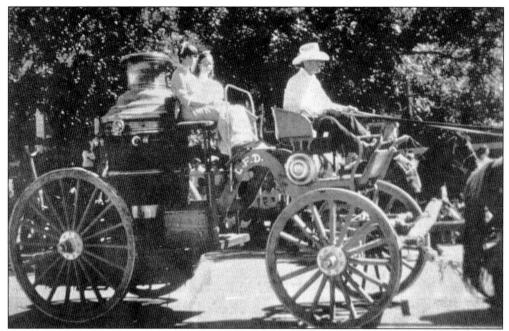

**NOT A STANLEY STEAMER.** Used to fight fires, Laramie's 1907 steam engine somehow wound up in Cheyenne. Due to unclear ownership issues between Laramie and Cheyenne, litigation took place. The engine was returned to the city of Laramie, and the engine is now safely ensconced at the Laramie Plains Museum.

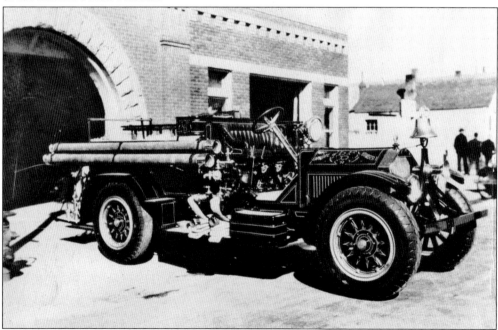

**FIRE TRUCK, 1920.** Over the years, Laramie has been plagued by a large number of fires. This 1920 view of the city's fire truck standing in front of the station located on the northwest corner of Second and Custer Streets shows that the city fathers were willing to do what was necessary to fight those fires.

# *Four*

# LARAMIE'S NOTORIOUS LEGENDS

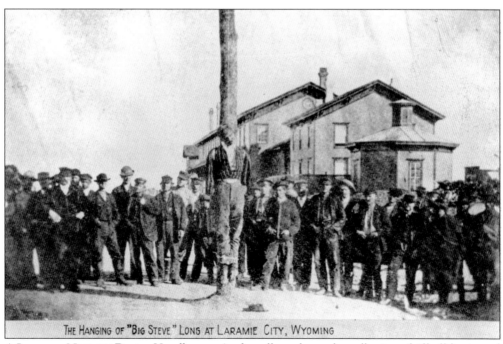

THE HANGING OF "BIG STEVE" LONG AT LARAMIE CITY, WYOMING

**A LARAMIE NECKTIE PARTY.** Hoodlums, ne'er-do-wells, and a motley collection of riffraff dominated the scene during the first few months of the town's existence. Finally, enough was enough. The vigilantes gradually caught the rascals, one of the worst being Big Steve Long. Upon his capture, he was hanged on the beam of a telegraph pole near the train depot.

**THE WILD WEST.** During its first few months of existence, Laramie was filled with desperadoes. A roster of those ne'er-do-wells reads like a list of who's who in hooliganism. Foremost on the list was A. M. Dalton, one of the infamous Dalton gang, who purchased a home at 517 South Seventh Street in Laramie. The Dalton family kept the property until they sold it in 1905.

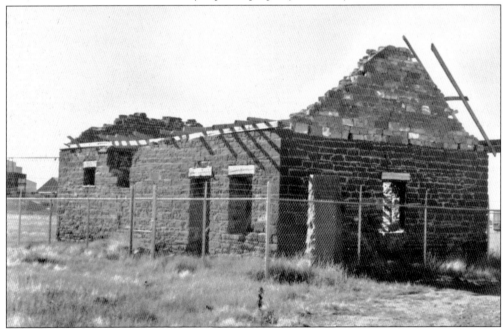

**JAILBIRDS WERE KEPT HERE.** When Fort Sanders was decommissioned in 1882, many of the wooden buildings at the fort were sold and brought to town. Unfortunately, because it was constructed of brick, the jailhouse or brig was simply left on the grounds to slowly deteriorate over the years.

**TOM HORN.** A real, live gunslinger, Horn saw his reputation develop into legendary proportions. He was hired by the Wyoming Stockgrowers Association to eliminate those who posed a threat to that association. His undoing came when he was convicted and hanged in 1903 for the killing of 12-year-old Willie Nickell over in the Iron Mountain area of the Laramie Range, northeast of Laramie. Allegedly, he intended to shoot Willie's father, a sheep rancher, and accidentally hit the boy instead. Questions still remain as to whether he is guilty.

**THERE'S BUTCH, ALRIGHT, BUT NO SUNDANCE.** From July 15, 1894, until January 19, 1896, Robert LeRoy Parker, also known as Butch Cassidy, was a guest of Wyoming's Territorial Prison, located just across the river from Laramie. A bank robber extraordinaire, he may actually have died of old age in 1937, rather than having been killed in San Vincente, Bolivia, in 1908.

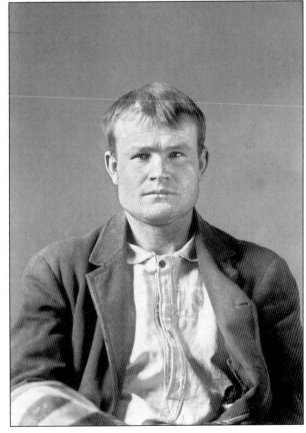

**ONE MORE HANGING IN LARAMIE.** On August 29, 1904, an escaped prisoner from the county courthouse grabbed a young woman by the name of Della Krause and slashed her throat. She survived the attack, but a mob captured the escapee and strung him up at a light pole across the street. As they hanged him, one of the onlookers emptied his six-gun in the man.

**THE COURTHOUSE.** Located in Laramie, the first Albany County Courthouse was built in 1871. Much later, a new courthouse was built. Prosecuting attorney Stephen W. Downey was on hand to officially dedicate the new building. Then, 60 years later, his son Corbet took part in the dedication of another new courthouse, which replaced the old one.

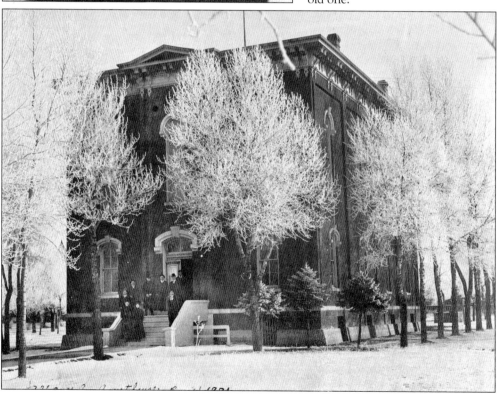

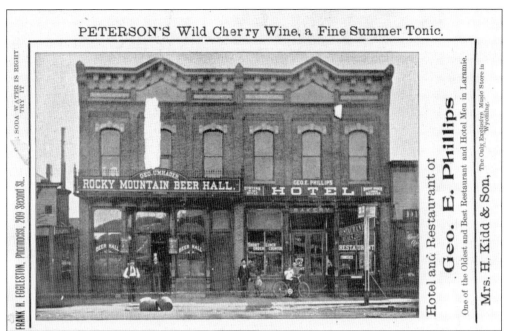

**BELLY UP TO THE BAR.** The Rocky Mountain Beer Hall was one of Laramie's favorite watering holes. Next to the beer hall was the Phillips Hotel, with rooms covering the second floor. For two weeks in 1892, twenty-five Texas gunmen were incarcerated in that hotel while they waited to be taken to Cheyenne to stand trial for the murder of two men in Johnson County. Once there, they were charged with the crime and released under their own recognizance. That ended it, and they never had to stand trial.

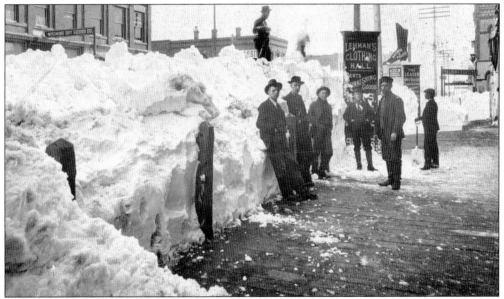

**LET IT SNOW!** In 1897, Laramie got a whopper of a snowstorm! The white stuff was so deep in some parts of the business district that one could literally step out and onto the snow from a second-story window. Luckily for these fellows, the walks had already been cleared off at Lehman's Clothing at 216 South Second Street.

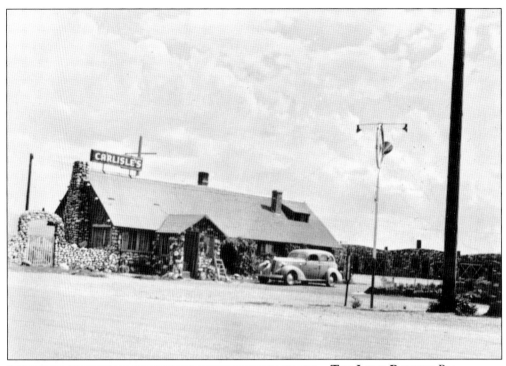

**THE LONE BANDIT.** Between 1916 and 1919, Bill Carlisle robbed a total of four trains that ran between Laramie and Cheyenne. His total take was only $1,032.23, and when he was caught in 1919, he was sent to prison in Rawlins for a number of years. Upon his release, he and his wife opened and ran the Cottage Court Motel at Thirtieth Street and Grand Avenue until his retirement in the early 1950s.

**IN THE LINE OF DUTY.** Outlaw Frank Bray gunned down Albany County sheriff Charles Cosby (pictured here) on April 17, 1927. Cosby had been in office for only three years and was the third Albany County sheriff to be assassinated. Soon after, Deputy Sheriff Welliever avenged his death.

# Laramie Brewery.

O. P. TOWNSEND, Sole Proprietor.

## THE FINEST GRADES OF BEER.

This is a Home Product, and Guaranteed to be
Equal to the Very Best.

## SPECIAL ATTENTION GIVEN TO ORDERS FROM OUTSIDE THE CITY.

TEMPLE OF ECONOMY. Rubber Goods.

TEMPLE OF ECONOMY, Toys and Fancy Goods.

DIRECTORY OF LARAMIE

84

CHARLES N. SETTELE for Allegretti's, Lowney's and Plow's Candies.

**THE LARAMIE BREWERY.** Well established by 1897, the Laramie Brewery did a brisk business until the advent of Prohibition in 1919. The brewery was located just to the west of U.S. Highway 30, about a half mile north of town. The brewery did not bottle its own beer. That job was left to the Laramie Bottling Works, located downtown.

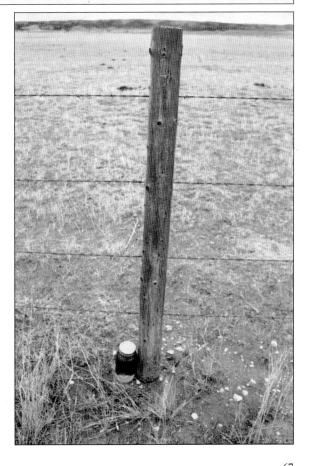

**BOOTLEG BOOZE.** Some of the ranchers around Laramie had their own stills during Prohibition, and the "White Lightning" that they manufactured was sold on the honor system. A patron would leave his money in a mason jar next to a certain fence post, close to a county road. The next day, he would return and find his jar filled with that magical liquid.

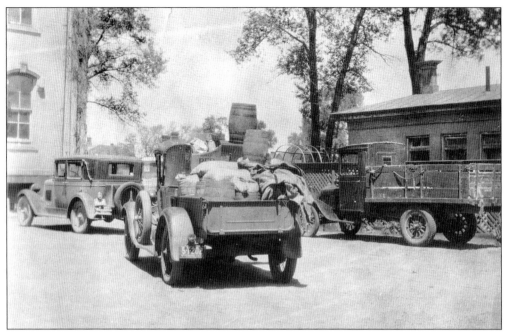

**THE MOONSHINE BLUES.** It was 1930, and sheriff deputies Phil Kuntz and Charles Petersen escorted "Doc" Donahue's car, which was loaded with moonshine and the various supplies that he needed to distill the stuff, off to the pokey. If convicted, the good "Doc" would be spending a number of years at the prison up in Rawlins.

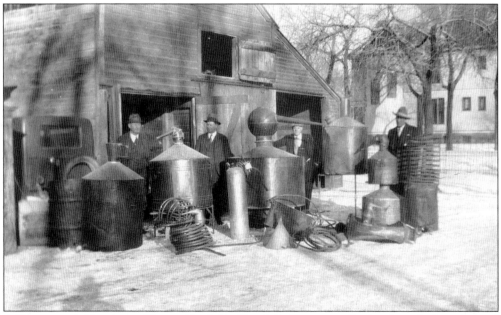

**A REVENUER'S ROUNDUP.** The spoils of this illegal distillery were displayed on the lawn behind the old courthouse in Laramie. Evidently, from left to right, Barret Cole (jailer), Joe Lane (undersheriff), Phil Kuntz (deputy), and Edwin Baily (sheriff) were as proud as they could be for finding and confiscating this still, which was discovered out at Red Mountain at the southern end of the county.

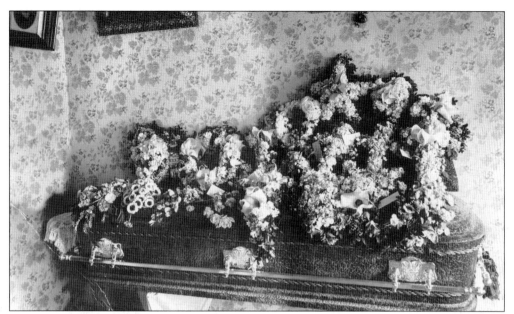

**So Long, Goodbye, and Farewell.** In Laramie, as elsewhere, the American way of death has always been graced with an abundance of flowers. Today, except for the casket piece, flower bouquets replace the old-fashioned funeral sprays. Thus, once the funeral is over, the bouquets can be passed around for others to enjoy, while the funeral sprays are simply left at the grave site.

**Where Have All the Sporting Houses Gone?** From 1868 until 1959, Laramie had more than its share of bordellos, which were located at a variety of places around town. The glory days of those "dens of iniquity" were the 1930s and 1940s, and during that time, there were four such houses, all located on the second floor of the 200 block of South First Street.

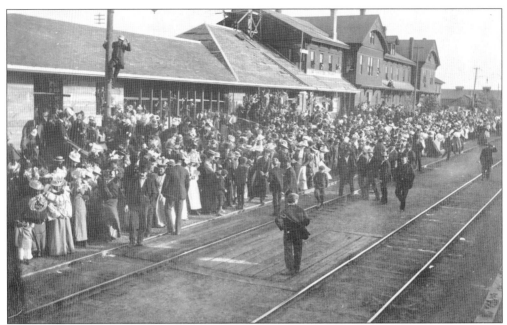

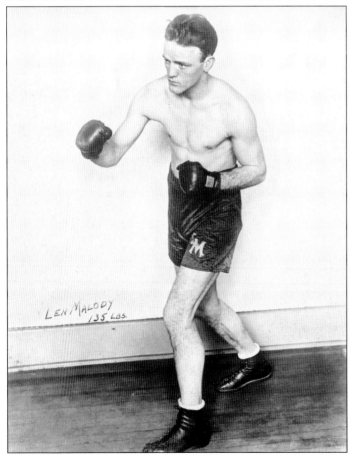

LEN MALODY
135 LBS.

**SOLDIERS ARRIVE HOME.** The Spanish-American War was fought between 1898 and 1903. During that time, a train carrying a troop load of soldiers who fought in that war arrived in Laramie. It appears as if the whole town turned out to welcome the boys home.

**PUT UP YOUR DUKES.** For a number of years, the sport of boxing was quite fashionable, even in Laramie. From the looks of this 1922 photograph, Leonard Malody was ready and willing to go a few rounds. Boxing matches were very popular out at Woods Landing, 30 miles west of town. More than a few college students put themselves through school by taking part in those weekend matches.

*Five*

# A Respectable Town

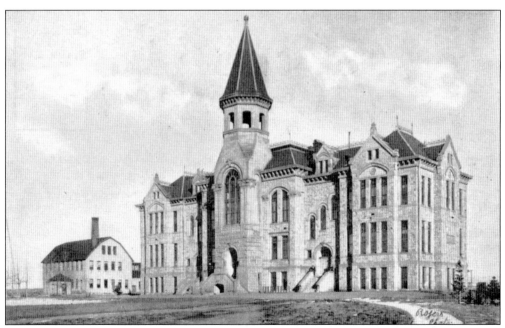

**The Hall of Languages.** Constructed with the founding of the University of Wyoming in 1886, Old Main (here in this 1910 view) shows what the building was like at the time. Despite the removal of the tower in 1917 and the complete remodeling of the building in 1950, it remains the center of university life.

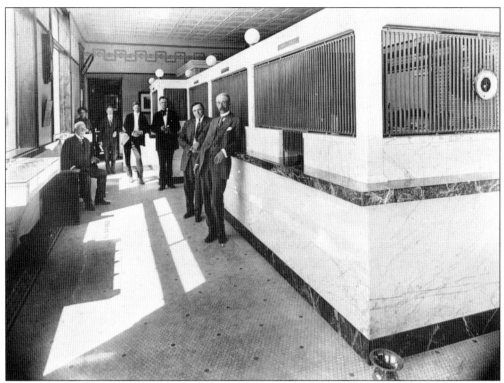

**No Charge for Using the Spittoon.** From 1872 until 1938, this was the interior of the First National Bank, located on the northeast corner of Second Street and Thornburgh (Ivinson) Avenue in Laramie. Photographed here are, from left to right, Edward Ivinson, Bess Langdon, W. W. Jones, Oscar Challman, T. H. Therkildsen, B. C. Daly, and H. R. Butler.

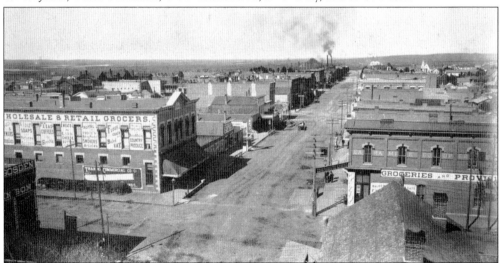

**Bird's-Eye View of Laramie.** Looking north on Second Street from the Garfield Street intersection, this view of Laramie was probably taken sometime in the early 1880s. It is possible that building on the left may have been the Laramie Grocery, and the building directly across the street might have been the Trabing Commercial Company. Conflicting notes from other historic photographs do not clarify the locations.

# THE LARAMIE Boomerang

**THE *LARAMIE SENTINEL*.** Born in 1850, Edgar Wilson "Bill" Nye came to Laramie as a young journalist and went to work for James H. Hayford, who published the *Laramie Sentinel*. In 1881, he began publishing the *Laramie Boomerang*, which is still being published today. Bill left Laramie in 1883 and became one of the country's most famous humorists until his death in 1896.

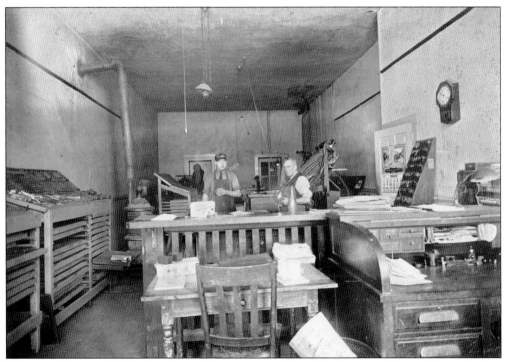

**STOP THE PRESSES!** Until the advent of computers and the chips they use, Ottmar Merganthaler's linotype composing machine, first introduced in 1886, made it faster and easier for the newspapers to have their articles composed, set to type, and printed. This 1925 photograph is possibly the interior of the *Laramie Boomerang*, with a linotype machine located in the background at far right.

**PRINCIPAL MOORE.** Martha Moore is pictured standing in front of Washington School, which was completed in 1911. During that same year, she was appointed principal of the brand-new Stanton, or North Side, School. During the 1910–1911 school year, Stanton School served as Laramie's first high school, which had a graduating class of nine students.

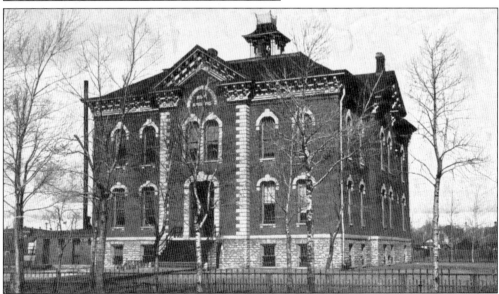

**THEY CAME FROM ALL OVER TOWN.** In 1878, a bond issue was passed, allowing the community to build a brand-new school named East Side School. For a number of years, Laramie's school system only went through the 10th grade. For those wishing to continue their education, they had to attend University Prep on the University of Wyoming campus.

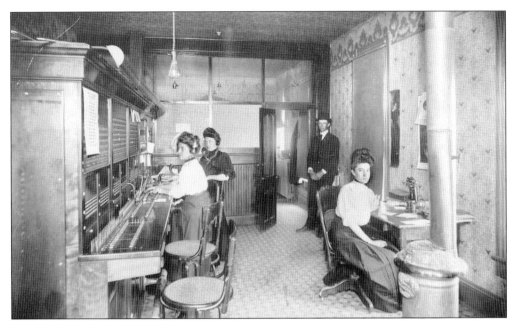

**HELLO, MYRT.** In 1882, Laramie got its first telephone exchange, located on the second floor of a nondescript building on the northwest corner of Second Street and Grand Avenue. Since all phone calls had to go through a central switchboard, it wasn't long before callers were on a first-name basis with the switchboard operators.

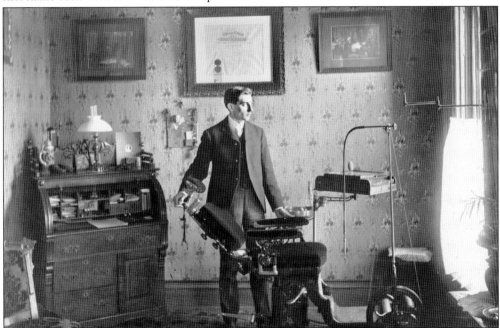

**DENTIST McNIFF.** Well established by 1901, Dr. P. C. McNiff was one of four dentists who practiced their profession in Laramie. His business was still going strong after the other three had disappeared from the scene. Dr. McNiff's office was located on the second floor of the Temple of Economy building, which was on the southwest corner of Second Street and Thornburgh (Ivinson) Avenue.

**THE POSTMASTER.** Elmer Beltz was Laramie's postmaster for over 30 years and began his career before the beginning of the 20th century. Although a good and sympathetic employer, there were times when his patience was tried. One morning, when all of the carriers were busy sorting the mail for the day's deliveries, one of the carriers, in a religious fit, threw himself down on the floor and started rolling about. Beltz was summoned, and once there, he looked down and said, "My God, man, what's the matter with you?" It was then that the carrier replied, "I just seen God." "Is that so," came the reply from Beltz. "Well, if you see him again on the job, you're fired."

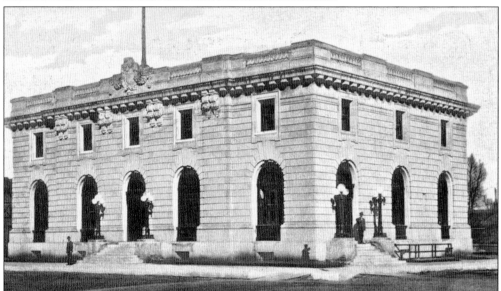

**A NEW POST OFFICE.** Laramie was finally getting a new post office in 1905, constructed of limestone and located on the corner of Third Street and Thornburgh (Ivinson) Avenue. The accepted design for the new building was referred to as neo-Italian Renaissance style. The first floor was used for the community's postal needs, while the second floor was rented to the U.S. Forest Service. It served Laramie until 1956.

**THE EAGLE IS LANDING.** Perched atop this hexagon-shaped memorial, this eagle proudly sits above an alphabetical list (cast in bronze) of all those Wyoming veterans who served in the Great War, now called World War I. Edward Ivinson had this memorial, located right in the center of the intersection of Second Street and Thornburgh (Ivinson) Avenue, created in 1922. Eventually traffic got too heavy, and it was moved to Court House Square where it remains today.

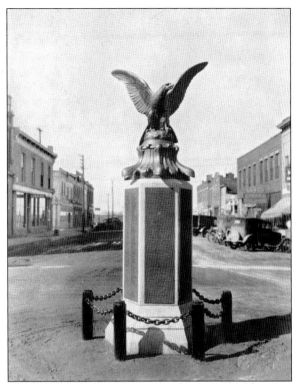

**THE LINCOLN HIGHWAY.** Completed in 1915, the highway ran from New York City to San Francisco, and the nice thing about it was the fact that it ran right through Laramie, Wyoming. It would be years before it was all covered with either blacktop or concrete. When Interstate 80 was completed in the early 1970s, much of it was plowed under and redone as part of the interstate.

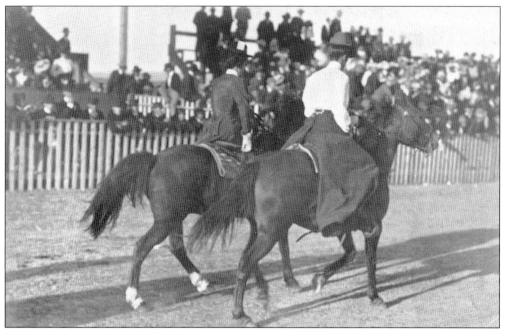

**A Day at the Races.** The Albany County fairgrounds, southeast of Eighteenth Street and Grand Avenue, was the setting for this race that occurred right around the beginning of the 20th century. It looks as if the lady in the white blouse, possibly Anne Haley, was a bit ahead of her competitor as they both raced for the finish line.

**Elizabeth Pilbrook.** In 1915, Elizabeth Grow Pilbrook was all dressed up and ready to have her picture taken. Hats were a basic part of any woman's wardrobe and included long, needle-like pins, which were stuck through the hat and into the hair to keep it in place on a windy day.

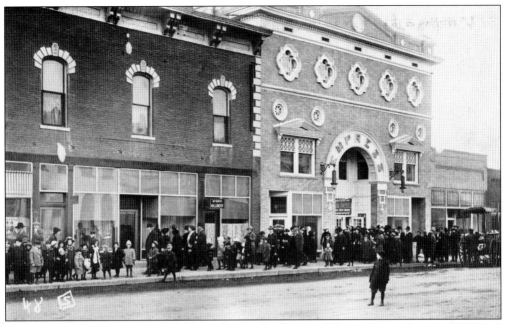

**THE EMPRESS THEATER.** From 1912 until 1939, the Empress Theater, located in the 100 block of South Second Street, was most likely the fanciest theater in town. The movies shown there graduated from the old silent movies to the talkies in 1929. Completely remodeled in 1939 and renamed the Fox Theater, it remained in business until the early 1970s.

**AN EVENING OF ENTERTAINMENT.** It all took place under the direction of William Marquardt's Mannerchor Hall, owned by the Mannerchor Society on Third Street between Grand Avenue and Garfield Street. The title of this show was *Murray and Mack Shooting the Chuts*. It has been said that the gentleman in the top hat was none other than Mack Sennett before he went to Hollywood to become famous with his Keystone Kops.

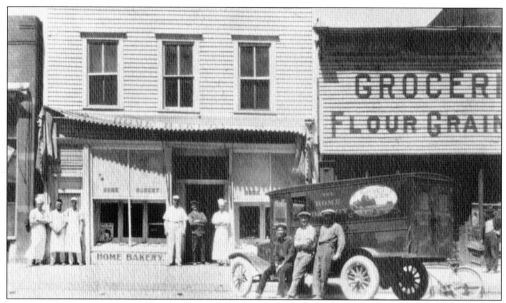

**THE HOME BAKERY.** In 1918, Richard Eberhart, a German immigrant, purchased this building at 304 South Second Street for use as his Home Bakery business. Although the building was worn out and needed repairs, he managed to use it until 1924, when it was decided that Eberhart would have the above structure torn down and a new one constructed on the same site. The Eberhart family remained in the baking business for 76 years before finally selling to Kim Gamble, an Australian immigrant, who still owns and operates the bakery today. It is one of the most comforting sites in Laramie and one of the most delicious.

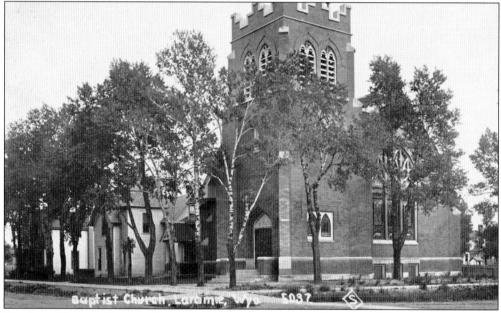

**THE FIRST BAPTIST CHURCH.** Located at the southeast corner of Fourth and Grand Avenue, the first Laramie church was dedicated in 1870 and served the congregation until it was destroyed by fire in 1904. A new church, pictured here, replaced the old one and was used until another was completed on the corner of Fifteenth and Sully Streets in 1962, where it serves the faithful today.

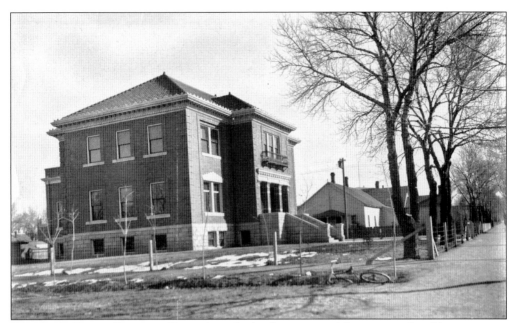

**LARAMIE'S PUBLIC LIBRARY.** If it ain't in the book, it just can't happen, so the old army saying goes. Laramie's Public Library at Fourth Street and Grand Avenue first opened for business on February 2, 1887. In 1902, Eli Crumrine and Dr. Aven Nelson applied for and received a grant of $20,000 from the Andrew Carnegie Foundation on the condition that they would only use $2,000 a year of that money for maintenance.

**A BOOK BRIGADE.** In 1981, Laramie built a brand-new library. The old library was located down the street just four blocks away. With scads of volunteers, a human chain was formed, and individuals standing next to each other passed books from one to another all the way up the street, from the old library to the new facility.

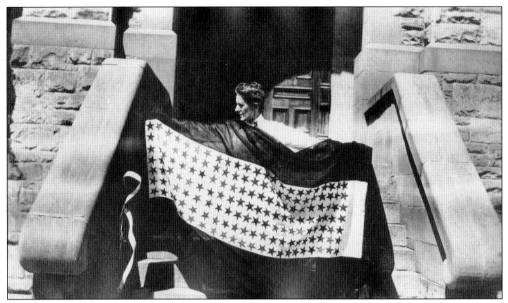

**MISS UNIVERSITY OF WYOMING.** During her tenure, Grace Raymond Hebard was a little bit of everything to the university. She served as president of the local camera club, secretary of the Agriculture Experimental Station, business manager of the *Wyoming School Journal*, member of the State Board of Examiners, University of Wyoming librarian, member of the committee on Rhodes Scholarships, and, in 1906, professor of political economy.

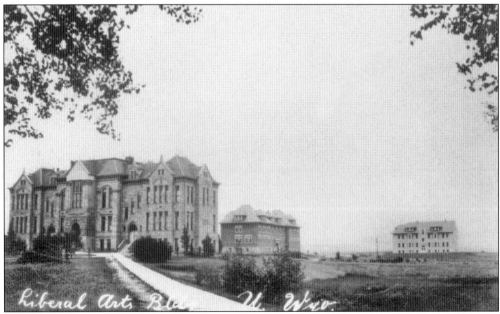

**SUCH A BARREN CAMPUS.** One almost needs a scorecard to keep up with the name changes of the building called Hall of Languages, Old Main, or the Liberal Arts Building. Merica Hall could be seen just to the right of it. At the time of the photograph, only the north half of Hoyt Hall, which was another women's dorm, had been completed.

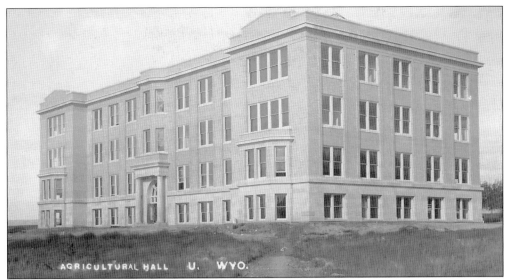

AGRICULTURAL HALL    U.    WYO.

UNIVERSITY CONSTRUCTION. The agriculture building on the university campus was completed in 1922. However, its construction presents sort of a mystery. The vast majority of the university buildings were all built with sandstone and are of a similar construction; the one above stands out as dramatically different, as do Merica Hall, the Commons Cafeteria, and the little Music Building.

RAH, TEAM. "Seven come eleven, red come white, Laramie High School, fight fight fight." It was a terrific cheer to urge the home team on to victory. At the time, the high school sports that attracted the most attention were basketball and football, and back then, only boys were allowed to participate on the varsity teams.

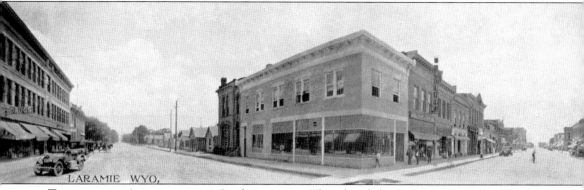

**THORNBURGH AVENUE IN 1910.** Looking west on Thornburgh (Ivinson) Avenue, the old depot at the end of the street dominates the scene. The Laramie Drug Company is the first building to

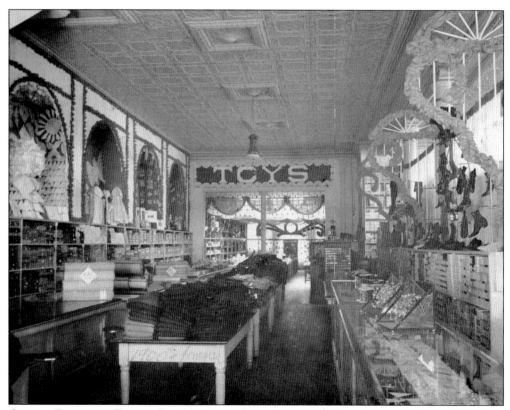

**ORDERS PROMPTLY FILLED.** By 1901, W. H. Frazee's store, the Leader, was well established on the northwest corner of Second Street and Grand Avenue in Laramie. The store offered a wide variety of merchandise, which included shoes and boots, a millinery department, men's clothing, dry goods, ladies' furnishing departments, carpets, drapery, and crock.

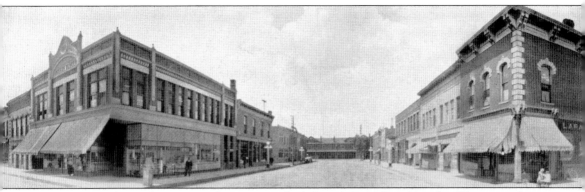

the extreme right, and just across the street, to the left, is A. E. Miller's Temple of Economy. On the left and across the alley is the Kuster House.

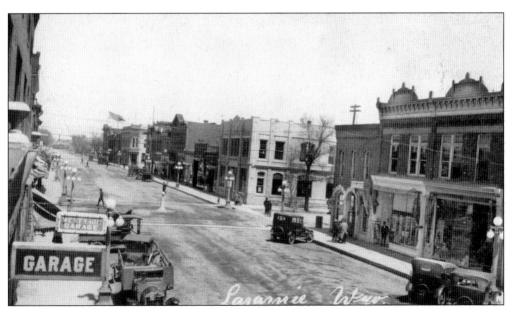

**THE 1920s.** Prohibition was in full swing in 1925, and Second Street in Laramie never looked better. On January 5, Nellie Tayloe Ross of Wyoming was inaugurated as the first woman governor in American history. The 1920s were celebratory times of risk, prosperity, and change for Laramie and the United States.

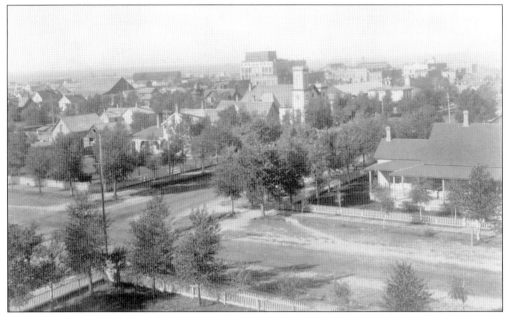

**VIEW FROM THE COURTHOUSE.** It was a summer day in 1898, and Laramie looked good as the camera faced south and west from Fifth Street and Grand Avenue. The centerpiece of the photograph was the old Baptist church, which burned down in 1904. N. K. Boswell's home was on the extreme right and was one of the buildings brought in from Fort Sanders when it was decommissioned in 1882.

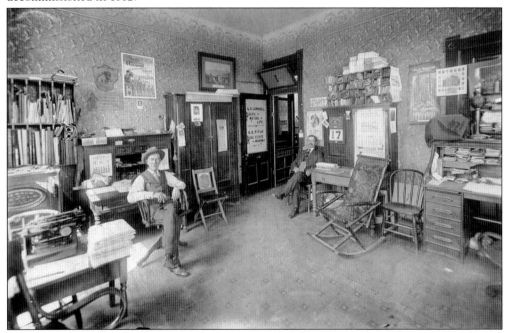

**ANOTHER DAY AT THE OFFICE.** Selling both real estate and insurance, G. A. Campbell and R. E. Fitch rented the office space on the second floor of the Albany National Bank Building at 222 Grand Avenue. Here Ned (left) and R. E. (Roy) Fitch (right) sit comfortably in their office during the summer of 1908.

# Six

# Dawn of a New Century

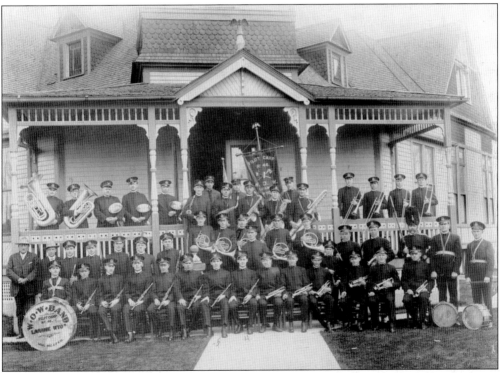

**THE WOODMEN OF THE WORLD.** The Woodmen of the World was a fraternal organization that probably had one of the best bands in Laramie. Sometime after the beginning of the 20th century, they built this magnificent building, which diagonally faced the northeast corner of Fifth Street and University Avenue. It was torn down when a new post office and parking lot were built on that site in 1960.

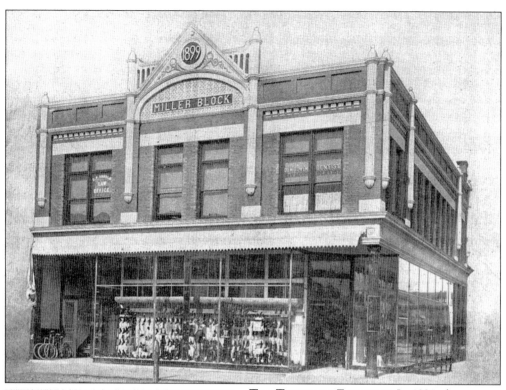

**THE TEMPLE OF ECONOMY.** In 1891, the country was caught in the throes of an economic depression. It was then that businessman A. E. Miller built what was to become the Miller Block Building on the southwest corner of Second Street and Thornburgh (Ivinson) Avenue. Selling mercantile goods at reduced prices, he was quite successful, despite the economic downturn that the country was suffering.

**ADVERTISING.** There was certainly no shortage of advertisers in the 1901 Laramie City Directory. (Even the Territorial Prison was featured on a column strip.) Elmer Lovejoy was Laramie's mechanical genius with automobiles, inventing a steering knuckle that is still used on vehicles today. Carl Petersen, an immigrant from Sweden, was one of those able to make the American dream come true until his untimely death in 1908.

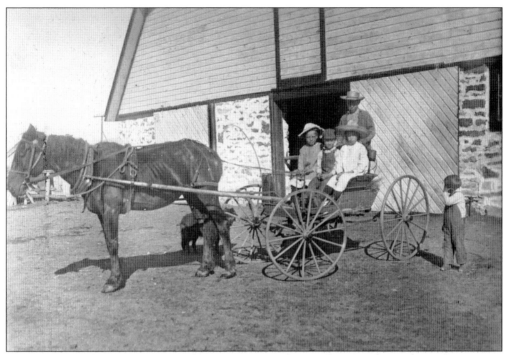

**SCHOOL DAYS.** Rural schools have always been important in the state of Wyoming. Back then, kids either walked or were driven by horse and buggy to school, as seen in this 1911 photograph. It was not unusual for the schoolmarms to take their room and board with a family of one of the children that they were teaching.

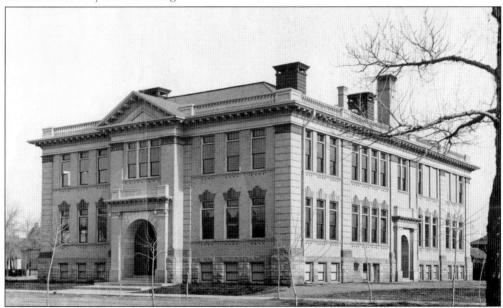

**WASHINGTON SCHOOL.** Completed in 1911, Washington School was a proud addition to Albany County's School District No. 1. Originally it was built as a high school, but as time went on, the high school was moved, and it became a school for elementary children. About 1992, the school board finally closed it down for good, and the building was sold and converted into apartments.

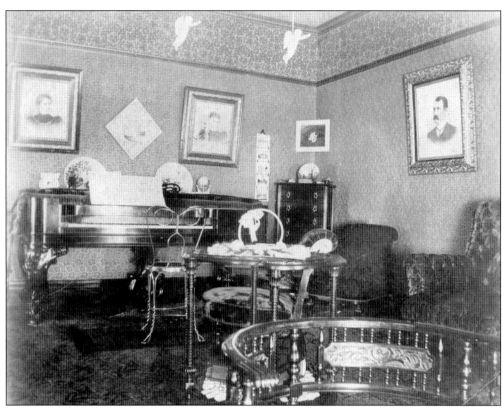

**NO PLACE LIKE HOME.** Most likely shown during the last decade of the 19th century, this middle-class parlor in Laramie was fairly typical of what could be found in many such homes at the time. A piano was always a necessity for entertainment if company came to call. This ice-cream chair must have been a good conversation starter after the guests were seated for a visit.

**JOHN CRAPPER'S INVENTION.** From early on, many of the homes in Laramie had a freshwater well in one corner of their yard and an outdoor privy in another corner. Then in 1888, an Englishman by the name of John Crapper invented the flush toilet. It would be the beginning of the 20th century before Laramie could take advantage of that invention, after the city began installing water and sewer lines.

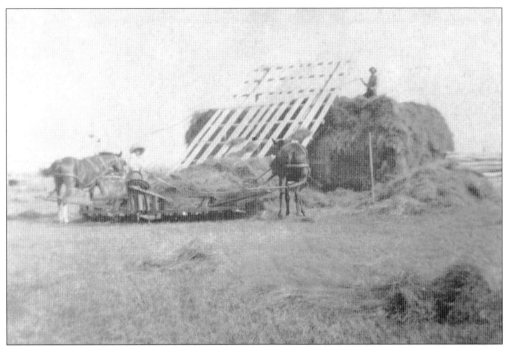

PUTTIN' UP HAY. Both cattle and sheep needed the locally grown hay to survive harsh winters and pastures affected by droughts. "Haying" is the process by which the feed is cut, stacked, and stored to feed livestock during the winter. In this haying photograph, a horse-powered crib is used to push the freshly cut hay up to the top of the rack where it was then dumped into the stack.

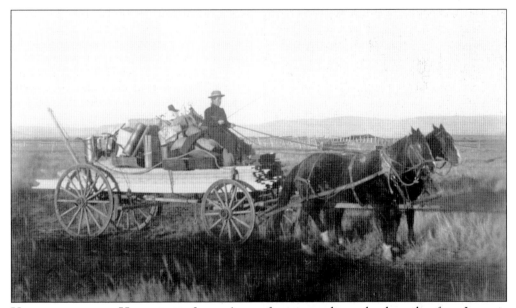

VICTUALS FOR THE HOMESTEAD. It wasn't easy for any rancher to haul supplies from Laramie out to the ranch to feed everybody. Driving a horse-drawn wagon to town and back could take one or two days, depending on how far one lived from town. In 1908, Kerry Greaser experienced no trouble at all as she headed home with her wagon loaded with supplies.

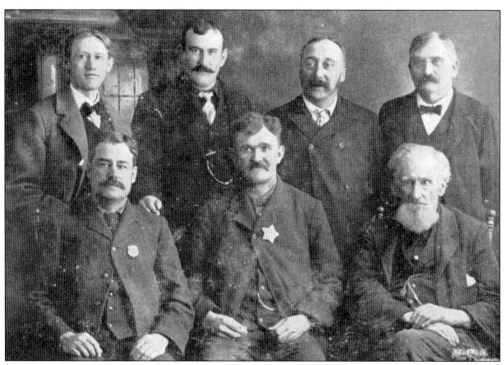

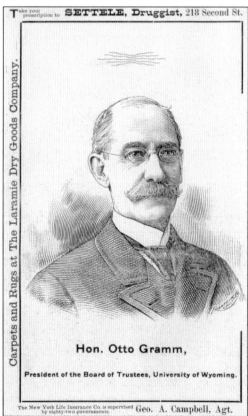

MOSSBACKS GALORE. The 1901 city council included Spaulding, Negus, McCullaugh, and Groesbeck, then Davis, Miles, and Hayford, and this was the outfit that ran the town. Back then, the mayor directed business at hand. At the time, there was no such thing as a city manager or thoughts at all about environmental impact or federal grants.

THE HONORABLE OTTO GRAMM. Otto Gramm (1846–1927), along with Edward Ivinson, was a kingpin in Laramie's development. Besides being an extremely astute businessman, as the owner and manager of the Laramie Coal Company, he also served as president of the University of Wyoming, Albany County treasurer, and probate judge.

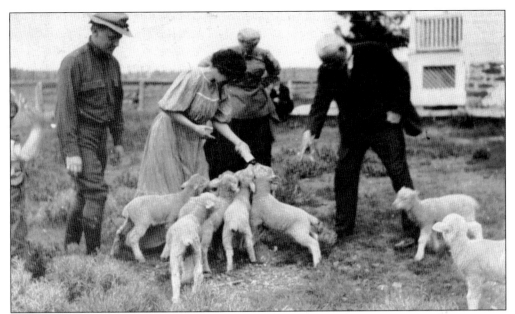

**WOOLLY BACKS.** Everybody was somehow involved in the Great War, 1917–1918. Suddenly America was caught up in the war against the terrible Hun. As a result, a great deal of wool was needed to help clothe those men in uniform. Because of this, the raising of sheep in Albany County became just as important as cattle ranching.

**MONEY IN THE BANK.** While it existed, the Albany County National Bank was probably the best one in the city for loaning the necessary funds to purchase a home. That service was so popular that those who borrowed from them usually referred to them as the "Building in Loan." Once said, everybody in town knew what they were talking about when referring to that bank.

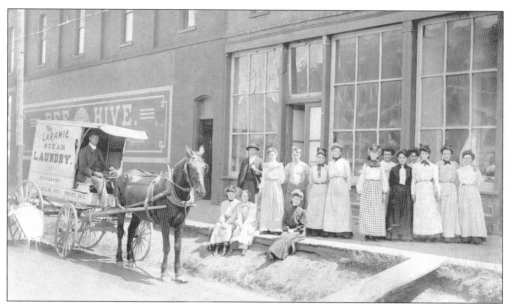

**LARAMIE STEAM LAUNDRY.** Frank Cook's Laramie Steam Laundry was located at 305 Garfield Street. This photograph was noted as being taken in 1900, although the owner did not appear in the 1901 City Directory. One can only assume that Cook was either sitting in the carriage or standing just to the left of the women, who were probably employed by the laundry.

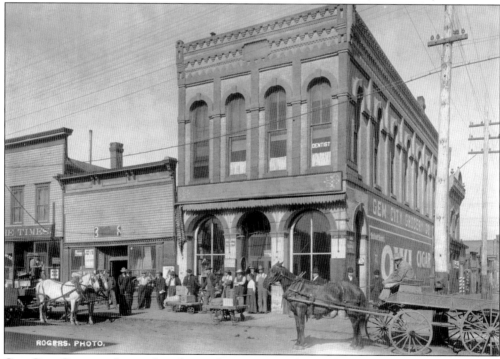

**GEM CITY GROCERY.** Located on the northwest corner of Second Street and Grand Avenue, this store first opened its doors in 1902. It was a stock company owned and operated by the employees as well as the owners of the company. James "Sunny Jim" Christensen, with Helen Ryan as his secretary, managed it. The store served Laramie until about 1949.

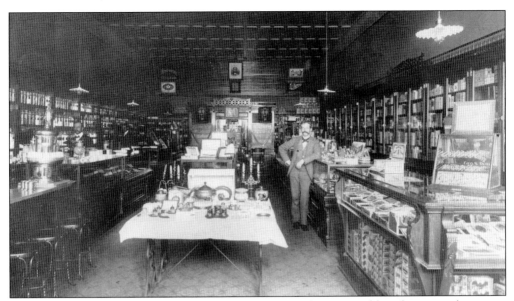

**A BOTTLE OF SARSAPARILLA, PLEASE.** A. H. "Pop" Cordiner earned his pharmacist license in 1896. He worked for the Eggleston Drug Store at 209 South Second Street and later established his own drugstore at 311 South Second Street. When Eggleston retired, Cordiner moved his business into Eggleston's old drugstore and stayed there until his retirement in the mid-1950s.

**THE TRABING BROTHERS.** Soon after Laramie was founded, the Trabing brothers, Gus and Charlie, went into business hauling supplies for the Union Pacific Railroad to those isolated settlements near the railroad tracks. They soon expanded their outfit by hauling freight and merchandise north into the Sioux country up in the Big Horn Mountains. Disaster struck the Laramie office on March 14, 1895, when the company burned to the ground and one of the firefighters lost his life. A new building was soon constructed, and they were back in business. Soon after that, the Trabings opened the Blue Front Theater, which attracted troupes traveling across the country, who stopped to perform their shows in Laramie. By 1901, their store at 300 South Second Street offered a full range of general merchandise. Unfortunately by that time, Charlie had died, leaving family members Gus, George, Hannah, and Mable to carry on the family legacy.

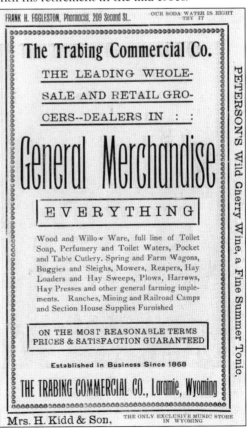

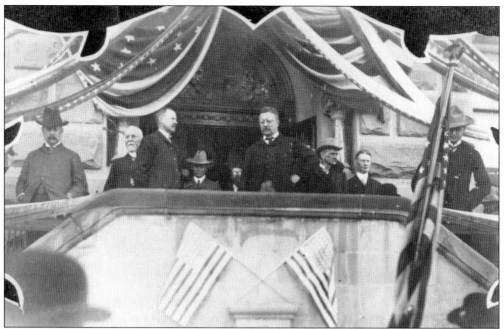

**MEMORIAL DAY SPEECH.** When Teddy Roosevelt came to town on Memorial Day 1903, he gave a speech from the porch of the Hall of Languages on the University of Wyoming campus. The only ones who can be identified, other than Roosevelt standing in the center, are Edward Ivinson, second from the left, and W. H. Holliday, standing sixth from the left.

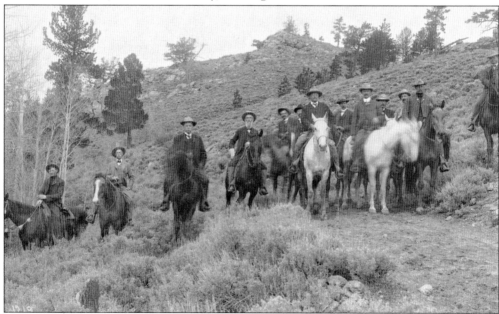

**RIDING THE RANGE.** On Memorial Day 1903, Pres. Teddy Roosevelt arrived in town by train from the West Coast. He was taken up to the Hall of Languages at the university, where he gave a short speech. President Roosevelt, on the white horse in the center, along with a group of prominent Laramie citizens, then rode to Cheyenne. Once there, the president caught a train back to Washington.

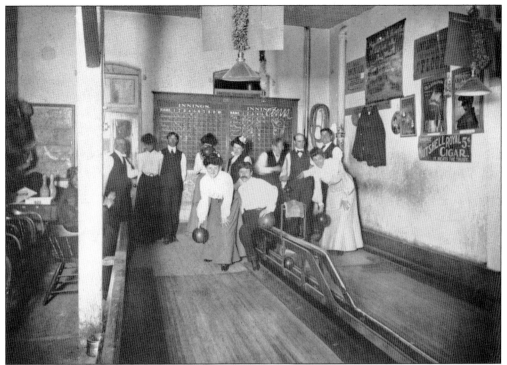

**DUCKPIN BOWLING.** The old city hall, pictured here *c.* 1910, was located just to the south of the Elks Club in the 100 block of South Second Street in Laramie. Inside that building there was a duckpin bowling alley. Duckpins were shorter and larger in diameter than the regular pins; bowling balls were also smaller.

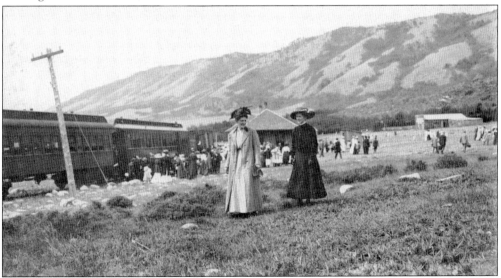

**"THE LAZY, NO PEP, AND WOBBLY."** Running from Laramie to Walden, Colorado (a distance of about 60 miles), the Laramie, North Park and Western Railroad, usually called "The Lazy, No Pep, and Wobbly," was completed in 1912. With a stopover in Centennial, Wyoming, passengers Mrs. Frank E. Hepner (left) and Mrs. Neva Nelson Ford step off the train for a few minutes to enjoy the mountain air.

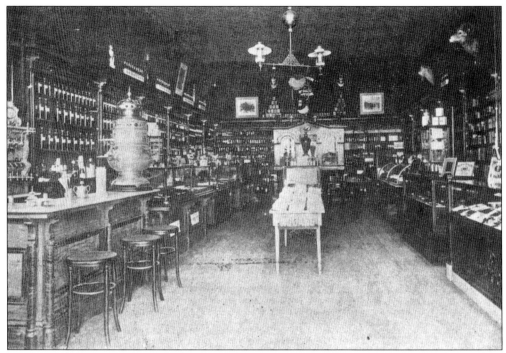

**SETTELE'S DRUGSTORE.** "Settele the Pioneer Druggist," so the 1901 City Directory advertisement states, was in business from the end of the 19th century until about 1911, and his drugstore was located at 218 South Second Street, in the Albany County National Bank Building. Back then, almost every drugstore had a soda fountain. There such confectionary delights as ice-cream sodas, milk shakes, malted milks, and banana splits could be had while the customer waited for his or her prescription to be filled. Except for a dish of ice cream covered with a topping and called a sundae, it was absolutely a no-no to sell any other type of soda fountain confection on Sunday.

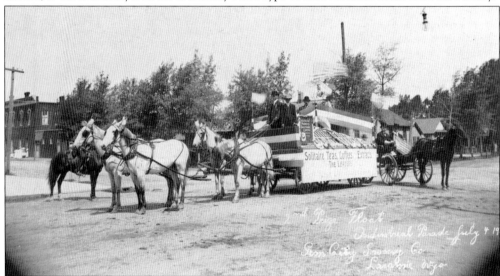

**FOURTH OF JULY PARADE.** Photographed here is the 1908 Fourth of July parade. The route ran from Second Street and Grand Avenue east to the county fairgrounds at Eighteenth Street. After the parade, a rodeo was held at the fairgrounds to celebrate that grand and glorious holiday.

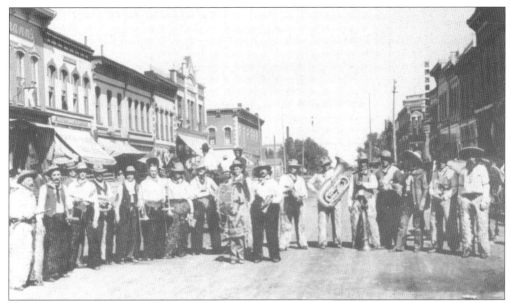

**STRIKE UP THE BAND.** After World War I, returning veterans established two organizations to promote their interests. One was the Veterans of Foreign Wars, which ruled that to belong, one had to have served overseas. The other organization was the American Legion, which was open to all veterans. This 1920 photograph shows Laramie's American Legion Post No. 14 band, ready to oompah-pah through any number of tunes.

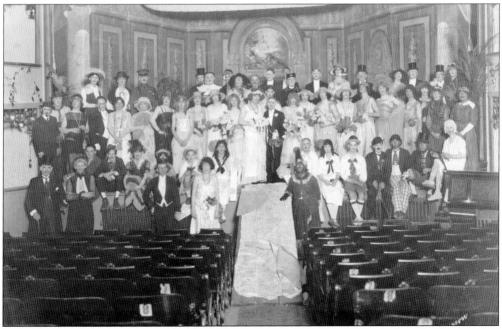

**A WOMANLESS WEDDING.** In 1920, entertainment was on everybody's mind across the country. New York became the theatrical center of the world, and Americans were all singing such popular songs as "Margie" and "Japanese Sandman." *Beyond the Horizon* opened in New York City, while *Sally*, a musical extravaganza, opened in New Amsterdam. With the cast and crew on stage, *A Womanless Wedding* opened at Root's Opera House here in Laramie.

**A Native Son.** Cecil Rogers (1891–1962) lived his whole life in Laramie, except for the time he spent serving in World War I. Dressed in an unknown uniform (note the UW on his cap), this 1912 photograph shows a bright young man ready to tackle the world. He made a long career of working for Laramie's post office, becoming assistant postmaster before his retirement.

**Uncle Sam's Army.** Stationed at Camp Lewis at American Lake, Washington, in 1918, Pvt. Roy Greaser, Company E Infantry, is pictured here in civilian clothes. Whether stationed stateside or overseas, a stint of military life always seemed to make a difference in how those men spent the rest of their lives.

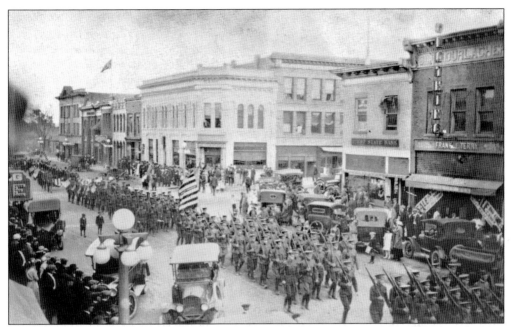

**MARCHING HOME.** The only thing known about these two photographs of downtown Laramie—full of vehicles, soldiers, and residents—is that they have something to do with World War I. One can only assume that it captured a moment in time following the armistice ending the war, which would make it after November 11, 1918. What a grand parade.

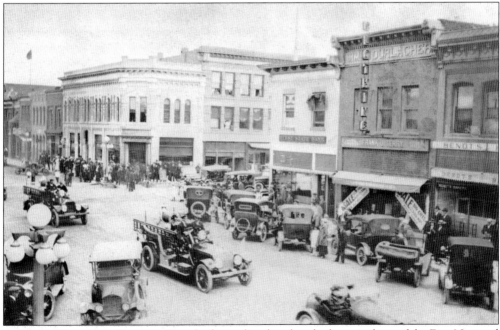

**A GRAND DAY FOR A PARADE.** Everybody was lined up for a look-see in front of the First National Bank on the corner of Second Street and Thornburgh (Ivinson) Avenue, next to the three-story Converse Building. Looking south across the street, the First State Bank was on the corner; next to it was Frank J. Terry's Clothing Store, located in the old Durlacher Building.

**WELL-REFINED LIMESTONE.** It was 1896 when the Standard Cement Plaster Company was formed in Laramie. Over the years, the plant has gone through many changes. Today it is known as the Mountain Cement Company, located just south of town. The raw material they use in making the cement is limestone, quarried east of Laramie, and mixed with shale and gypsum.

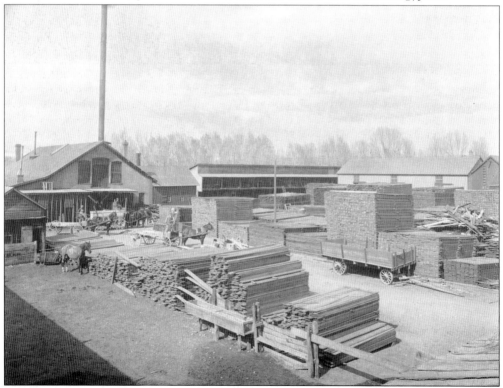

**HOLLIDAY'S LUMBERYARD.** By 1901, W. H. Holliday's lumberyard on 409–413 South Second Street was doing a tremendous business. Not only did he sell lumber, sawed and cut into a variety of shapes, but his company also built houses, especially those financed by the Albany National Bank in Laramie.

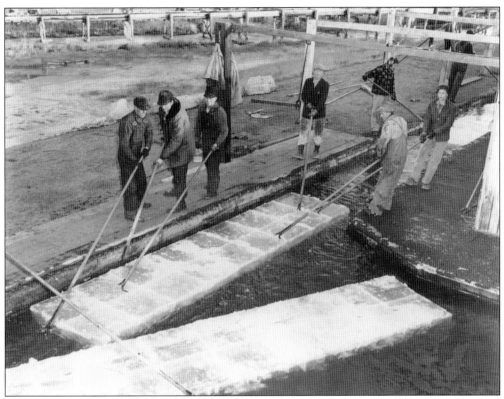

**THE ICEMAN COMETH.** From early on, the Union Pacific had an ice storage plant located where the interstate now crosses the Laramie River, south of town. During the winter, ice would be harvested from a pond by the river and stored in a large building next to the pond. In 1920, a new icehouse was constructed just west of the old Lincoln Highway, about a half-mile north of town. The new icehouse was about three-stories high, and once the ice was harvested, it was stored there until needed during the warmer weather. During the summer, groups of Hopi Indians would come north from Arizona and help the local crews load the produce trains with ice.

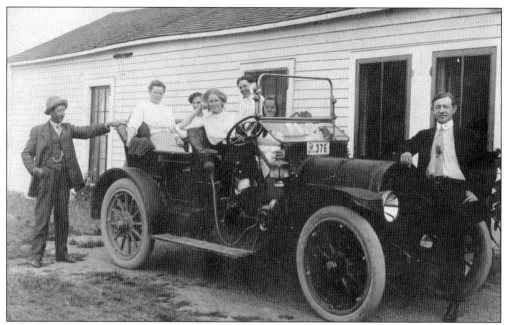

**A 1913 Automobile.** This automobile had a 1913 license plate, right-hand steering wheel, wooden wheel spokes, and leather straps to tie down the hood. The going price for such an automobile that year would have been around $400, give or take. From what can be determined, it was probably either a 1912 or 1913 Dodge touring car or a 1912 or 1913 Willy's Overland.

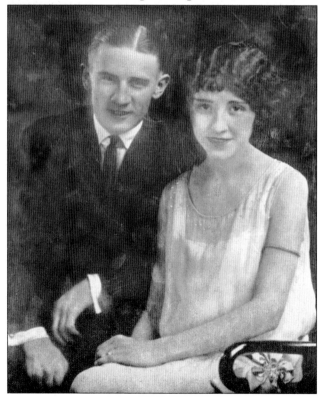

**A 1926 Wedding.** On February 7, 1926, Carl Eberhart of the Home Bakery married Marion Bullock at St. Laurence O'Toole Catholic Church in Laramie. Their marriage, which was blessed with three children, lasted a total of 72 years.

# *Seven*

# MODERN TIMES

**THE SWENSON-LUDWIG COLLECTION.** There is an old Chinese proverb that states, "One picture is worth a thousand words." That is certainly true of photographs taken by Henning Svenson, who arrived in Laramie in early September 1905. Henning photographed the Laramie area and residents, the Union Pacific Railroad, cowboys, outdoorsmen, Native Americans, what are now ghost towns, and scenic locations around Wyoming, including the Snowy Mountains, the Grand Tetons, Yellowstone, Laramie Peak, and many other wonders. After Henning passed away in 1932, his daughters operated the studio. Helen purchased the studio from her sisters, and in 1943, Lottie Ludwig and her husband, Walter, bought the studio from Helen and named it Ludwig Photo Enterprises. Ludwig Enterprises is still in business today, owned and operated by Anne Brande, Henning Svenson's great-granddaughter. The Svenson-Ludwig collection is an invaluable resource to historians and researchers today.

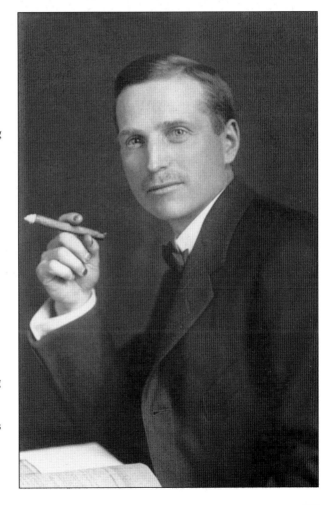

**WINGS OVER LARAMIE.** It was 1927, and the Great Depression was still a year and a half in the future. At the time, Fred Wahl, who owned a ranch south of town, established a Flying School. Standing in the photograph are, from left to right, Fred Wahl, the instructor; students Richard and Walter Wahl, and John Thalken. The plane was a Lincoln Standard and had a 180-horsepower Hispano water-cooled engine.

**THE FIREHOUSE GANG.** It was the Fourth of July 1929 when eight of Laramie's firefighters posed in front of the old firehouse on the corner of Third and Custer Streets. From left to right are George Carlson, Roy Barth, Al Barker, Ivan "Beanie" Stafford, James Miller, Alfred Nelson, Harry Braisted, and Blake Fanning.

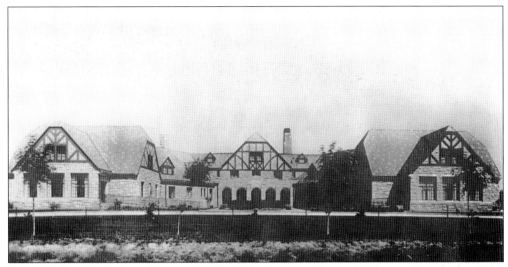

**IVINSON HOME FOR AGED LADIES.** Edward Ivinson, one of Laramie's first settlers, died in 1928. As a legacy to his late wife, Jane, he had this beautiful mansion constructed at 2017 Grand Avenue in 1930. It was to be a home for elderly ladies who were now alone and who wished to continue living in a home-like atmosphere.

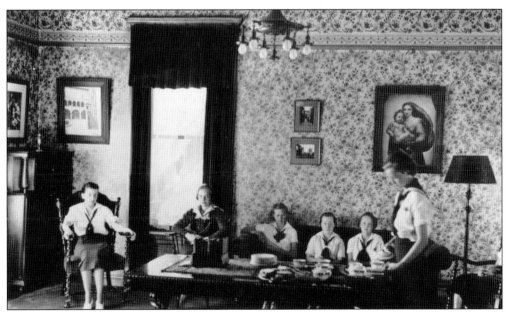

**IVINSON HALL.** Edward Ivinson donated his mansion to the Episcopal Church in 1921. The church then founded Ivinson Hall (1921–1958) as a high school for girls. The girls lived at the mansion and took their academic classes at University High (Prep), the Lab School at the University of Wyoming. Every Tuesday, the girls would gather at the mansion, as seen here, for high tea.

**EVERETT AND ARTHUR PETERSEN.** Everett Petersen (1898–1958), left, served in World War I and became a chauffeur to the army's surgeon general in France. Once home, he went to work for Gem City Grocery. Arthur Petersen (1900–1973), right, became a Laramie postal carrier, working under postmasters Elmer Beltz, Bert Holladay, and Fred Dudley. He took time off to serve in World War II.

**THE OLD MAN OF THE MOUNTAINS.** A lifelong resident of the mountains west of Laramie, Charlie Petersen (1877–1958) spent much of his career living in Albany, a hamlet about 35 miles west of town. Both he and his grandniece, Korine Sandman, stand in the door of a bunkhouse that Charlie built around 1935.

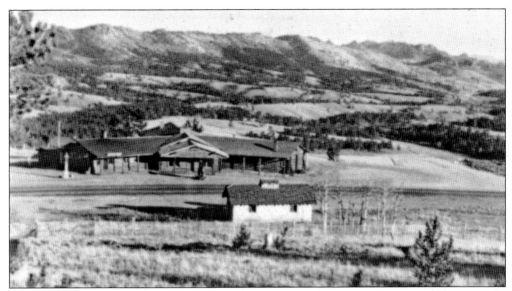

**Summit Tavern.** After the end of Prohibition, a combined bar and grill was erected at the summit of the Lincoln Highway, 12 miles east of Laramie, and lasted until the mid-1950s, when the building burned to the ground. No water was available for use at the tavern, so all water had to be hauled every day from town.

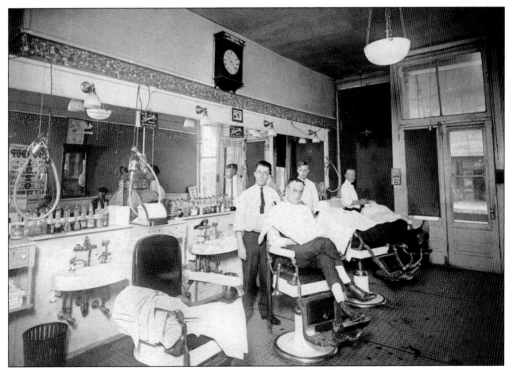

**The Midwest Barber Shop.** From about 1935 to 1965, Jacob Bouse owned and operated the Midwest Barber Shop, located at 205 Grand Avenue. Those working for him over the years included his two sons, Charles and Edward, along with longtime friend Les Canning.

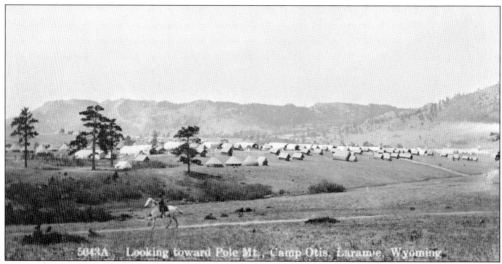

5043A   Looking toward Pole Mt., Camp Otis, Laramie, Wyoming

**BIVOUAC ON THE PRAIRIE.** From 1934 until 1942, the 115th Cavalry of the Wyoming National Guard held its summer training camps at Pole Mountain, about 15 miles east of Laramie. Composed of companies from all over the state, they were divided into two opposing groups called the Reds and the Blues. These two groups competed against each other during their war games.

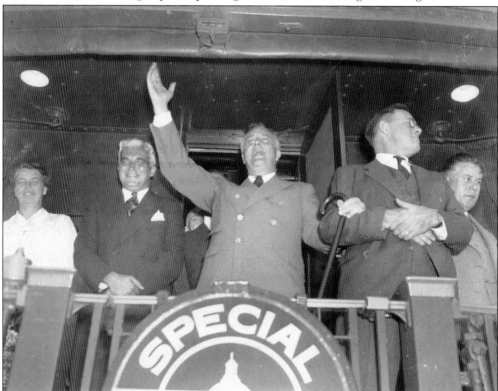

**FDR.** While running for his second presidential term during the summer of 1936, Pres. Franklin Delano Roosevelt (1882–1945) pulled into Laramie for a whistle-stop. He stood on a platform at the back end of the train and gave a short speech to the large crowd that had gathered to see him. Then he was on his way again, headed for the West Coast.

110

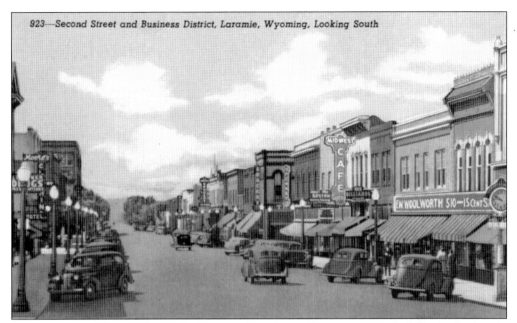

**ON THE EVE OF WORLD WAR II.** Looking south on Second Street in 1939, the following businesses are visible: Hurwitz's Midwest Trunk, Tom Cravens's Kassis Store for Women, Woolworth's, Harry Small's Rex Billiards Parlor, Tom Cambor's Midwest Café, Royer and DeHart's Shoe Store, Sweetbriar's women's clothing, and the Penney Building, with J. C. Penney's retail store on the ground floor and Dr. Stewart's office, Dr. Markley's office, and a beauty college on the second floor.

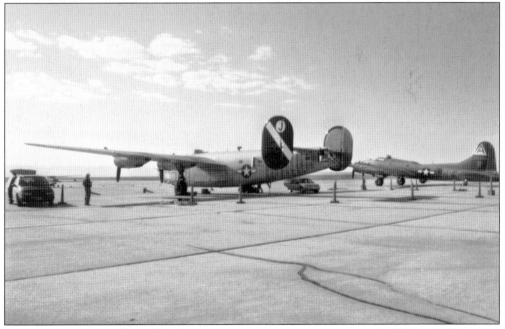

**WILD BLUE YONDER.** World War II was over but not quite forgotten. In July 1998, a B-24 Liberator Bomber and a B-17 Flying Fortress flew into Laramie for a three-day show. At a price tag of $300 apiece, those who wished to could get a 20-minute ride on the B-17.

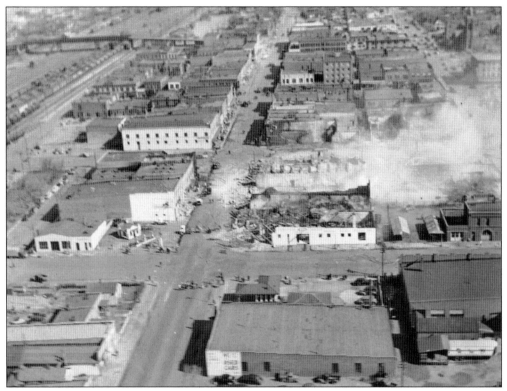

**A Terrible Day in Laramie.** It was April 15, 1948, the day after the big fire that destroyed the Holliday Building, warehouse, and surrounding businesses in downtown Laramie. However, things could have been worse. It has been said that the whole town might have gone up in smoke had not the wind changed that night.

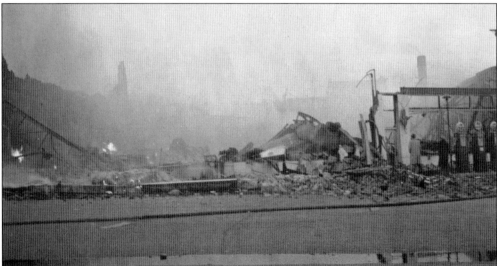

**Completely Burned Out.** Lou Mehse and Robert Baker watched in dismay as their Ford dealership, located on the northeast corner of Second and Custer Streets in Laramie, went up in flames during the disastrous Holliday fire on April 14, 1948. They lost everything, as did the Chrysler dealership at Third and Garfield Streets.

**THE BUCK STOPS HERE.** So said the plaque on Pres. Harry Truman's desk. In November 1949, he came through Laramie and gave a speech to a packed audience in the Arts and Sciences Auditorium on the University of Wyoming's campus. He brought the house down when he opened with "You know, I am real partial to Land Grant Colleges."

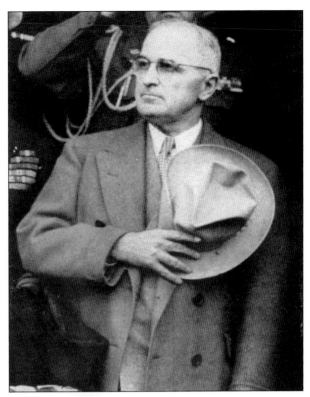

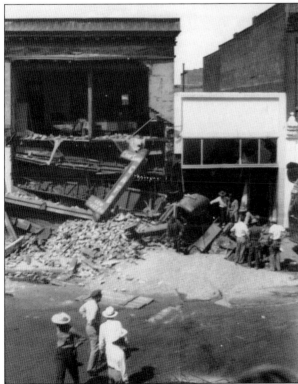

**AND THE WALLS CAME TUMBLING DOWN.** During the summer of 1949, an 18-wheeler lost its brakes coming down Telephone Canyon, east of Laramie. The driver was headed straight for the railroad tracks, which were filled with cars. A half a block away, he made a right turn and crashed into the New Canton Café before finally coming to a stop. Luckily, no one was hurt.

113

**THE 1950S.** In 1950, Laramie was still in the throes of a few growing pains. Evidence of this was seen when the university added a new football field and field house. With a mass of World War II vets returning to attend school, housing became a real problem. To fix that shortage, the university had two-story apartments built, as well as a number of rows of Butler Huts. These apartments allowed two families per hut, each of which had to share the same water closet. Seen at upper right center is a well-groomed open space with crisscross walks called Prexy's Pasture. Although the country was peacefully sailing along, it all ended suddenly with America's involvement in the Korean War. The top of the map faces west.

**A HISTORIC PUNCH BOWL.** When the battleship *Wyoming* was launched in 1911, a silver tea set was placed aboard the ship. The centerpiece of that set was the Sacajawea punch bowl, named after the famous Native American guide. When the ship was decommissioned in 1947, the set went to the Wyoming State Museum. Every Christmas, the bowl is brought to Laramie and used for the university's Christmas party.

**THE 141ST TANK BATTALION.** First organized in 1946, the 141st Tank Battalion included troopers from Laramie, Wheatland, Rawlins, Rock Springs, Kemmerer, and Afton. Only those troopers whose skills were needed found themselves in Korea. In 1952, the battalion as a whole was sent to Germany, where it remained until either late 1954 or early 1955, when it was disbanded.

**LEAVING HOME.** In September 1950, these members of the Headquarters Company of the 141st Tank Battalion of the Wyoming National Guard were marching south on Second Street toward the train depot. Because of the Korean War, the whole battalion had been nationalized and sent to Fort Campbell, Kentucky, for further training.

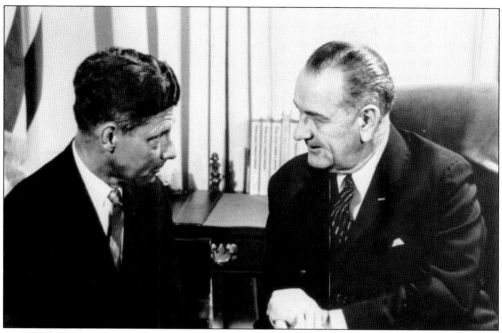

**PROFESSOR McGEE.** Gale McGee (1915–1992) taught American history at the University of Wyoming beginning in 1946. He ran for the U.S. Senate in 1958, was elected, and remained a Wyoming senator until his defeat in 1977. He was considered one of the most outstanding history professors ever to teach at the university.

**BRAND 'EM ALL.** Like the old cowman who told his men at branding time, "Put it on good, boys, she'll wear it all her life," the brand was the way the cowman displayed ownership of his cattle or horses. The branding iron, made of a chunk of patterned iron designed by the owner, was thrown into the fire until it was red hot, and then imprinted on the hide of the animal. In 1921, the idea of the branding iron gave the students at the University of Wyoming a catchy name for a newspaper. Affectionately called the *BI*, it is still published four times a week today.

116

**THE GREEKS HAVE A NAME FOR IT.** By 1950, the University of Wyoming had six sororities, including the Pi Phis (1910), the very first sorority to be established on campus; Kappa Delta, whose building was one of those brought into town from Fort Sanders after the post was decommissioned in 1882; Kappa Gamma; Tri Delta; Alpha Chi; and Chi Omega. Also included were the Varsity Villagers, who had no sorority house but lived in town. Not included here is Lambda Delta Sigma, which included both men and women.

Sororities
Chi Omega, Delta Delta Delta,
Kappa Delta, Varsity Villagers,
Kappa Kappa Gamma, Lambda Delta Sigma,
Pi Beta Phi.

Fraternities
Sigma Alpha Epsilon, Tau Kappa Epsilon,
Farmhouse, Kappa Sigma, Sigma Chi,
Sigma Nu, Alpha Chi Omega,
Sigma Phi Epsilon, Lambda Chi Alpha,
Alpha Tau Omega, Beta Theta Alpha,
Phi Delta Theta, Phi Kappa.

**IT'S ALL GREEK TO ME.** In 1950, one of the newest fraternities on the University of Wyoming campus was the Farmhouse, for those studying agriculture. Other fraternities included Sigma Phi Epsilon, Sigma Nu, Phi Kappa, Sigma Chi, Phi Delta, Lambda Chi Alpha, Kappa Sig, Alpha Tau Omega, Acadia, and, not to be forgotten, Sig Alpha.

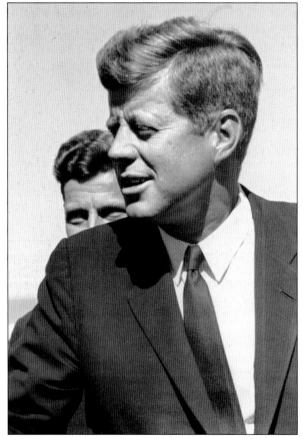

**A HOSPITAL FOR EVERYONE.** The Ivinson Memorial Hospital first opened its doors in 1976. It was dedicated to Edward Ivinson, who built a hospital at Tenth Street and Thornburgh (Ivinson) Avenue back in 1915. The emergency room entrance is pictured here on the left; the main entrance appears farther down. Since its construction, the hospital has added a cancer treatment center.

**THE END OF CAMELOT.** On September 25, 1963, Pres. John F. Kennedy flew into Laramie and gave a speech at the University of Wyoming's field house. Unbeknownst to all, the president had less than two months to live. He would be struck down by an assassin's bullet in Dallas, Texas, on November 22, thus ending Kennedy's rule of what some considered his Arthurian kingdom.

**Susan Laramie.** When Wyoming's U.S. senator Cliff Hansen was flying home on United Airlines from Washington, D.C., he began talking to one of the stewardesses. Much to his surprise, he discovered that her name was Susan Laramie, and that she was a direct descendant of Jacques LaRamee. Hansen worked with local officials to have Susan be the 1968 queen for Laramie's annual Jubilee Days celebration.

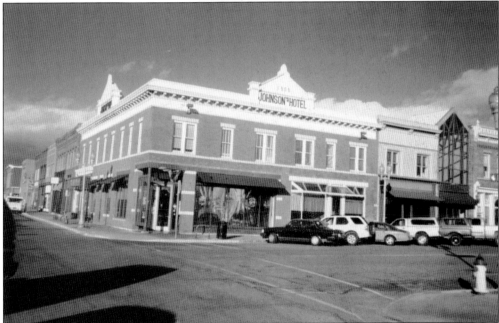

**The Johnson House.** Built in 1900 by John F. Johnson, the hotel became a Laramie landmark for years. According to the December 1905 *Laramie Republican Illustrated*, the hotel's Café and Grill was run by Ida Ehmka, which was one of the reasons for the hotel's popularity. The hotel was vacant from 1968 to 1974, when it became a rest home, then an alcoholic rehab center called Mission Possible. Today, after much remodeling and renovation, it holds Lovejoy's Bar and Grill.

**LARAMIE'S RECREATION CENTER.** In 2004, Laramie got its own recreation center, funded by Friends of Community Recreation, a 1¢ sales tax, and an endowment. There is something for everybody at this facility, including an eight-lane swimming pool, a leisure pool with submerged walking path, basketball court, and a tremendous variety of exercise machines. If fitness and recreation is what one is after, this is the place to do it all.

**HOME FOR CHILDREN.** In 1910, the Episcopal Church of Laramie established an orphanage, a refuge for dependent and homeless youngsters. By 1973, with the help of the local, state, and federal governments, the orphanage built a live-in community located 3 miles north of town, which still stands today.

**MONEY IN THE BANK.** The First National Bank, built in 1873, was located at 206–208 South Second Street on the northeast corner of Second Street and Thornburgh (Ivinson) Avenue from 1895 to 1938, when it was torn down and replaced. The bank bought most of a city block, razed the buildings, and built a new bank on the northwest corner of Third and Ivinson Avenue. The bank's name changed to First Interstate Bank in June 1980 and continues to serve customers.

**CREDIT UNION.** From banks to credit unions, Laramie has had a variety of financial institutions. One almost needs a scorecard to keep up with the name changes that occur with the banks. In 1990, the Albany County Public Employees Credit Union opened. In 1996, they moved to their present location on East Grand Avenue.

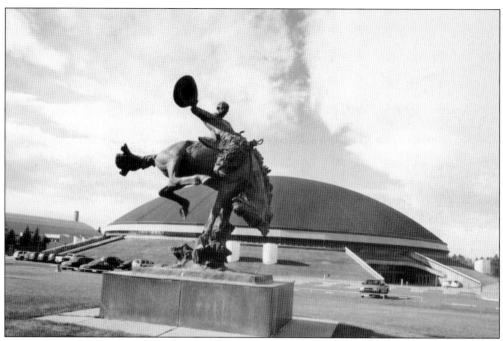

**STEAMBOAT.** Steamboat was a bronc that was impossible to ride. All the cowpoke had to do was stay on his back for eight seconds in order to take home the prize money, but it never happened. Once out of the chute, that horse would buck, twirl, then prance, kick, bounce, and dislodge his rider, well before the allotted time was up. A statue of Steamboat and an ever-hopeful cowboy was dedicated on the University of Wyoming's campus in 1991.

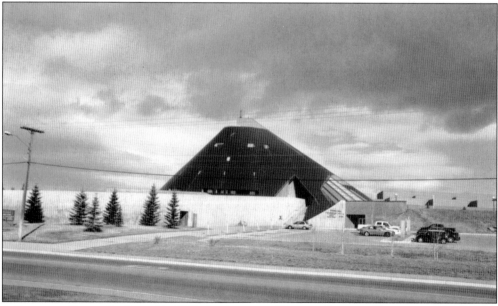

**A TEEPEE IN TOWN.** Dedicated in 1993, the American Heritage Center—University of Wyoming's archives, rare books, and manuscript repository—is definitely a place for learning. Few universities have special collections as extensive or as accessible as the AHC. Its collections of Western American history are phenomenal.

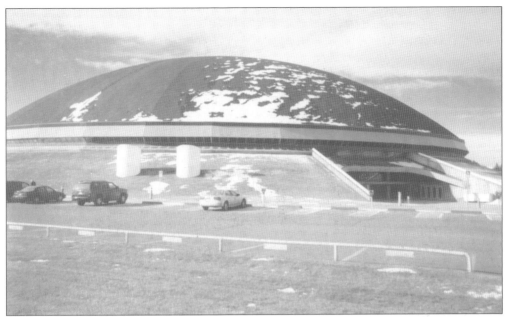

**DOME OF DOOM.** It is a mystery why the University of Wyoming's Arena Auditorium got the name Dome of Doom. Be that as it may, from the fall of 1981 until now, and with a total capacity of 15,000 spectators, it continues to serve the community as a basketball court, entertainment stage, and events center.

**CHIEF WASHAKIE.** This statue of Chief Washakie was dedicated on the University of Wyoming campus in 2005 and is a proud reminder of what an outstanding individual the chief was. Born about 1804 and raised with both the Lemhi and Bannock tribes, he became chief of the Shoshone Indians in 1850. Washakie, a great friend to the white man, always pushed for the betterment of his people. He ruled until his death in 1900.

**CROSSING OVER TO THE OTHER SIDE.** In 1929, the Garfield Street footbridge was built across the railroad tracks in Laramie. From the beginning, the bridge has had plenty of use. It was refurbished in the 1990s, and there are now plans in the works to construct lights along the pathway to make it easier for those who cross it at night.

**STANDARD OIL REFINERY.** Standard Oil of Ohio built a refinery on the west side of Laramie in 1915. That refinery operated until 1927, but when the company attempted to purchase more land from the Union Pacific Railroad to expand, the railroad refused to sell. Standard Oil simply abandoned the site and left town. This is all that is left of the old refinery.

**THIS IS THE ARMY.** The U.S. Army tried all sorts of gimmicks to entice young men and women to join the service. Located in the parking lot of the Banner Building on South Fourth Street, this colorful vehicle with a Web site and phone number was an effective way to attract those potential inductees.

**THE 133RD ARMY ENGINEERS.** Engineers grow hair in their ears, so the old army ditty goes. The 133rd Army Engineers Company of the Wyoming National Guard was formed on December 18, 1968, in Laramie, with a detachment in Wheatland. Very much active today, the unit has seen duty in and around Wyoming, South Dakota, New Mexico, Panama, Germany, and Iraq.

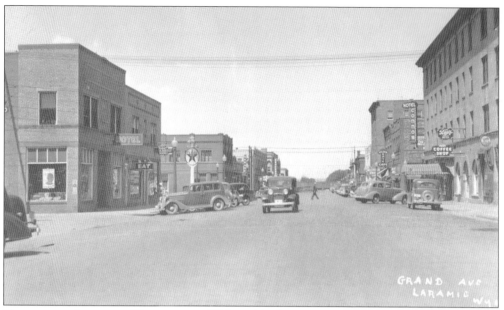

**DOWNTOWN LARAMIE.** The year was 1939, and looking west on Grand Avenue from Fourth Street, the Hotel d'Hamburger could be seen on the left, next to the Plaza Hotel, which was located upstairs over the Plaza Beauty Shop. Tatham's Filling Station was on the corner, while across the street to the right, the Connor Hotel and Coffee Shop were both open for business.

**SHERIFF BURNSTAD.** For 20 years, Ted Burnstad was sheriff of Albany County. Well-known and well liked, he had earned a bachelor's degree in political science and a law degree from the University of Wyoming before being elected to public office. He died in January 1973.

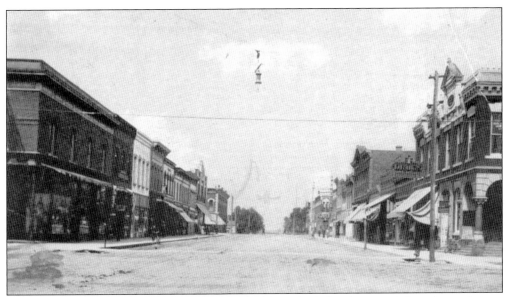

**WHO'S ON SECOND?** Although many of the buildings look familiar, much has changed since the beginning of the 20th century. Looking north on Second Street from the Garfield Street intersection, it is interesting to note who has awnings on the front of their business establishments. Many business names and owners have changed, but the buildings remain, and several have been renovated in recent years.

**LARAMIE COWBOY.** "Foot in the stirrup and hand on the horn, Best damned cowboy ever was born, Come a ti yi yippy, come a tee yi yay, ti yi yippy yi yay. Whoopie ti yi yo, git along little doggies, It's your misfortune and none of my own, Whoopie ti yi yo, git along little doggies, For you know Wyoming will be your new home."

# ACROSS AMERICA, PEOPLE ARE DISCOVERING SOMETHING WONDERFUL. THEIR HERITAGE.

Arcadia Publishing is the leading local history publisher in the United States. With more than 3,000 titles in print and hundreds of new titles released every year, Arcadia has extensive specialized experience chronicling the history of communities and celebrating America's hidden stories, bringing to life the people, places, and events from the past. To discover the history of other communities across the nation, please visit:

## www.arcadiapublishing.com

Customized search tools allow you to find regional history books about the town where you grew up, the cities where your friends and family live, the town where your parents met, or even that retirement spot you've been dreaming about.